Donated by

George and Unja

Varnuum

2010

Amish Life

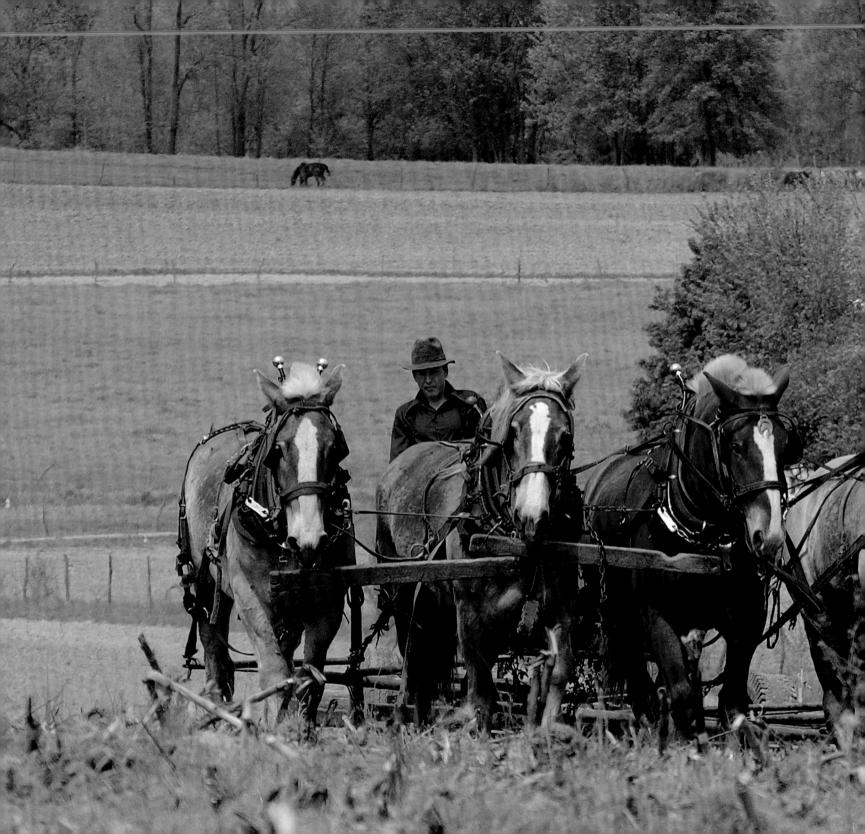

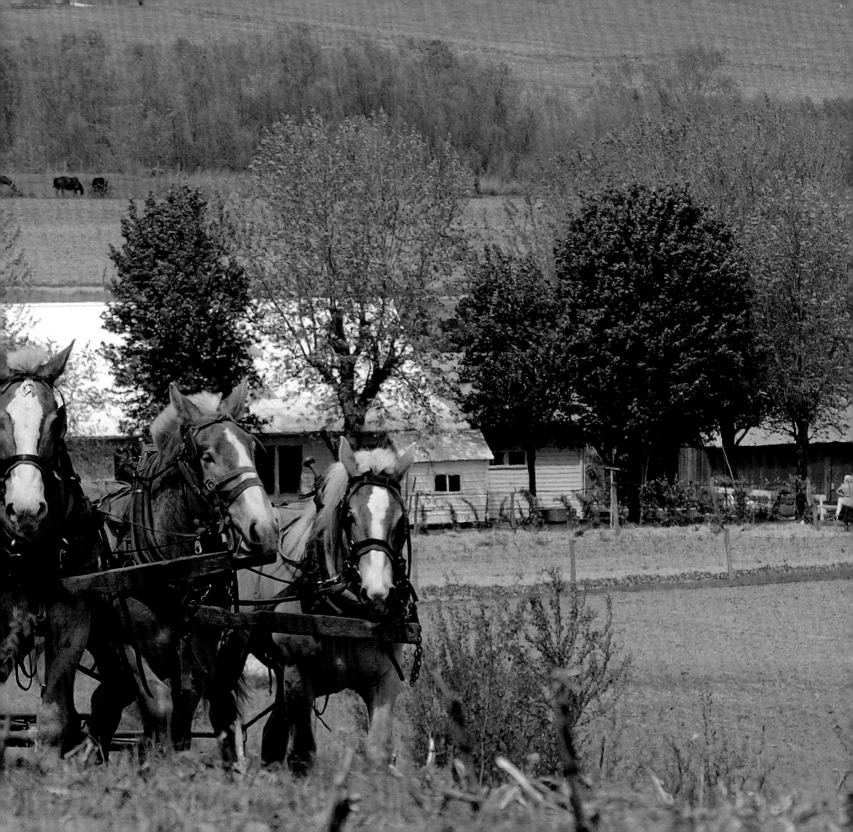

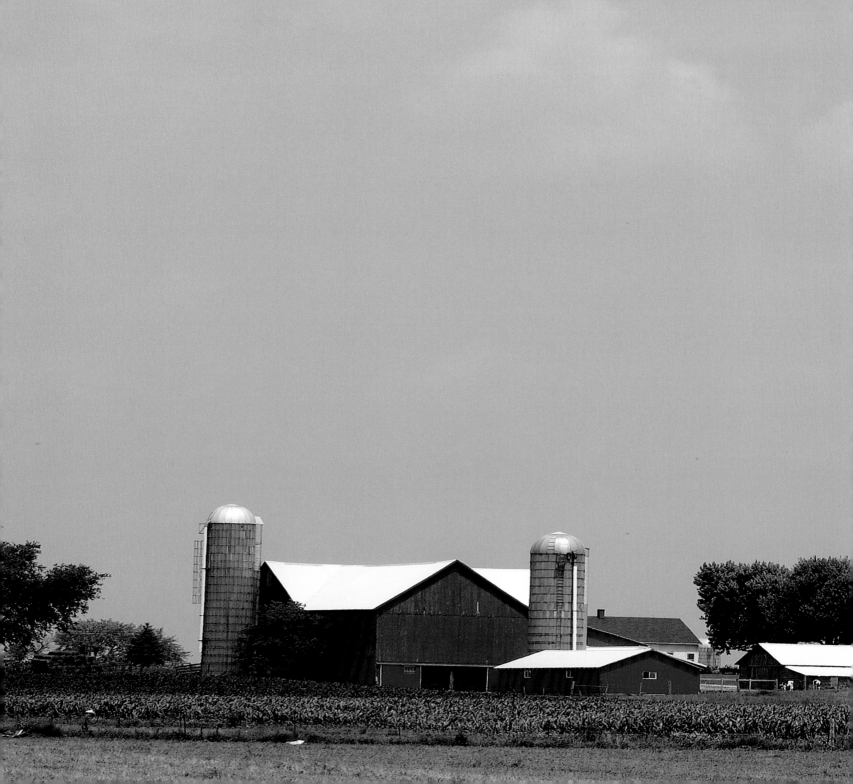

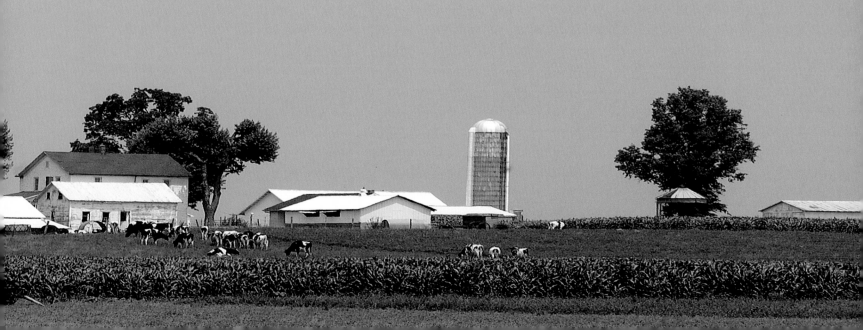

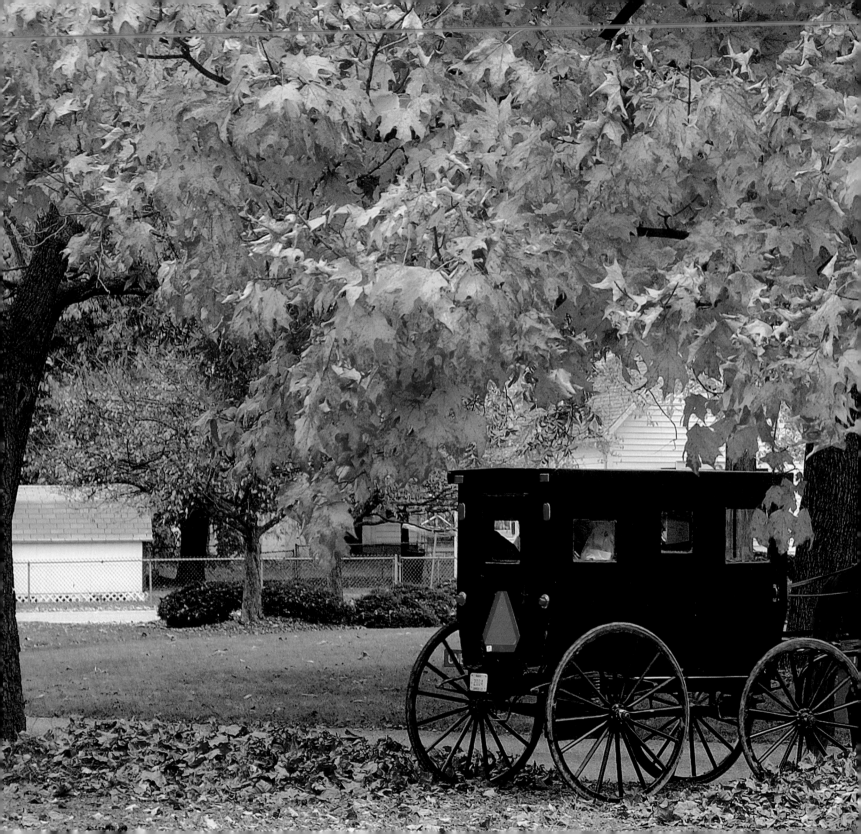

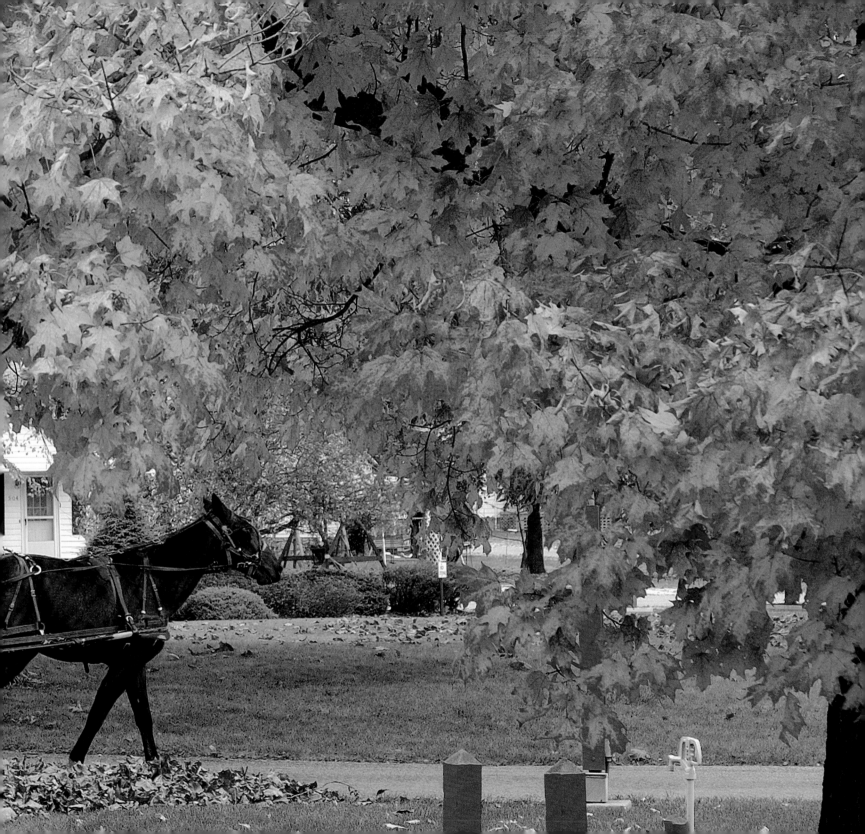

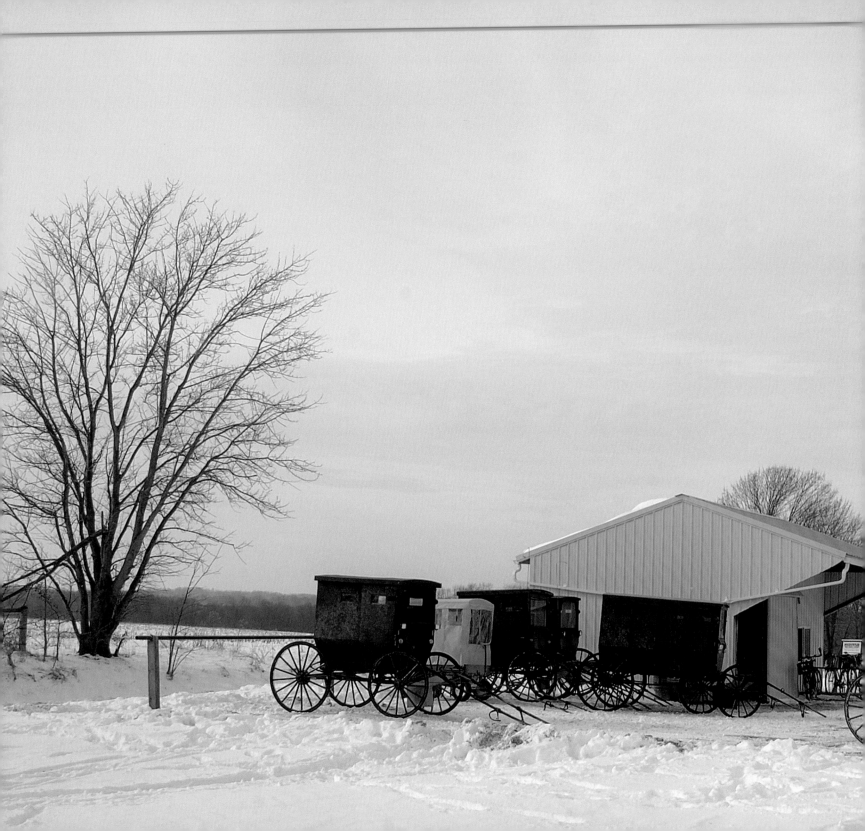

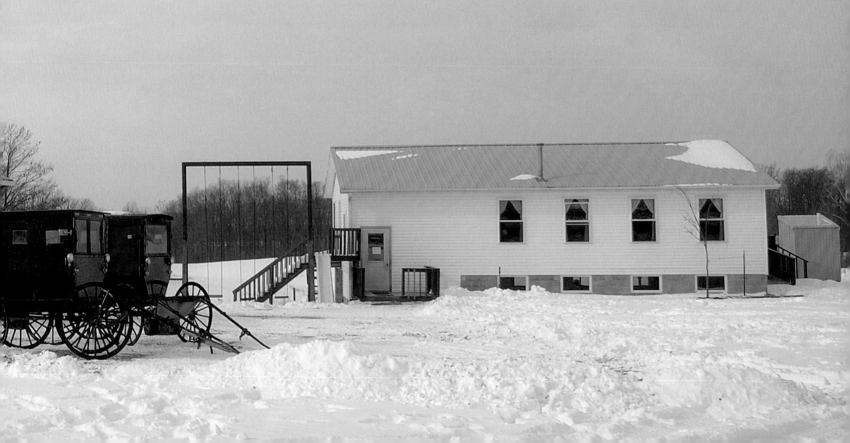

INDIANA UNIVERSITY PRESS Bloomington and Indianapolis

Amish Life

Living Plainly and Serving God

Darryl D. Jones

Foreword by Thomas J. Meyers and Steven M. Nolt

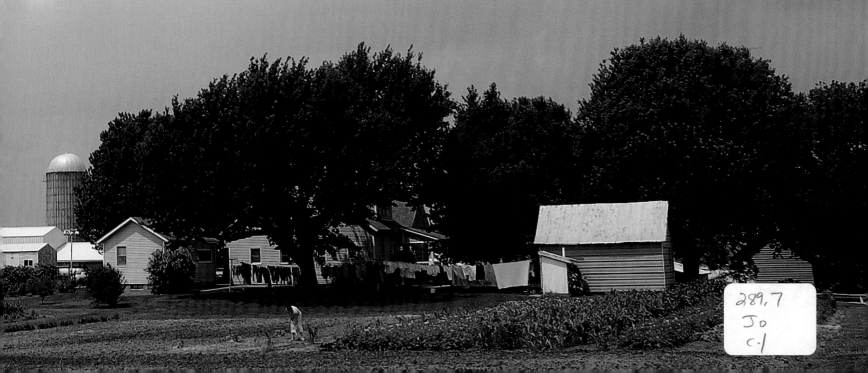

This book is a publication of

INDIANA UNIVERSITY PRESS

601 North Morton Street
Bloomington, IN 47404-3797 USA

http://iupress.indiana.edu

Telephone orders 800-842-6796
Fax orders 812-855-7931
Orders by e-mail iuporder@indiana.edu

MANUFACTURED IN CANADA

Cataloguing information is available from the Library of Congress.

ISBN 0-253-34594-4 (cl.)

1 2 3 4 5 10 09 08 07 06 05

I DEDICATE THIS BOOK TO MY WIFE, NANCY;
MY SON, AARON; MY DAUGHTER, HANNAH;
AND MY 91-YEAR-OLD FATHER, WILLIAM B. JONES, JR.

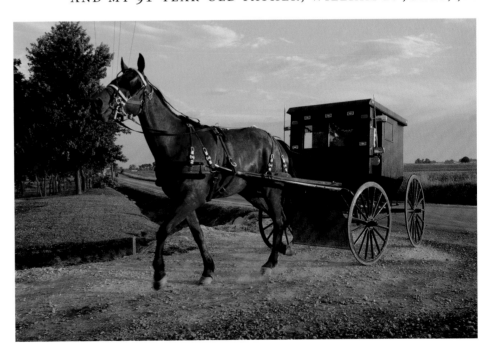

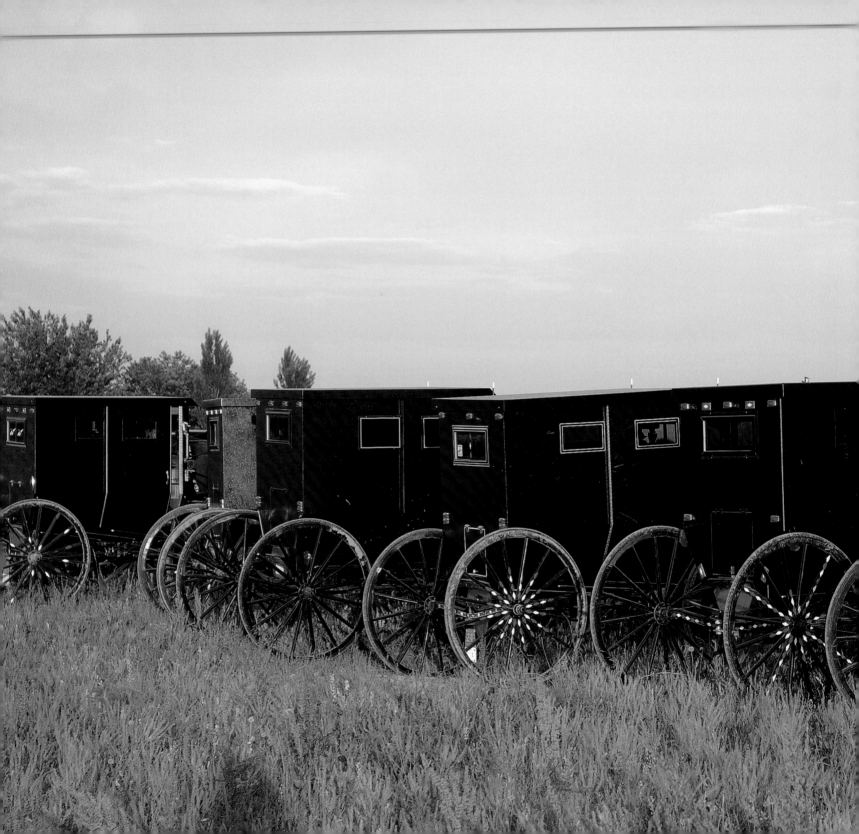

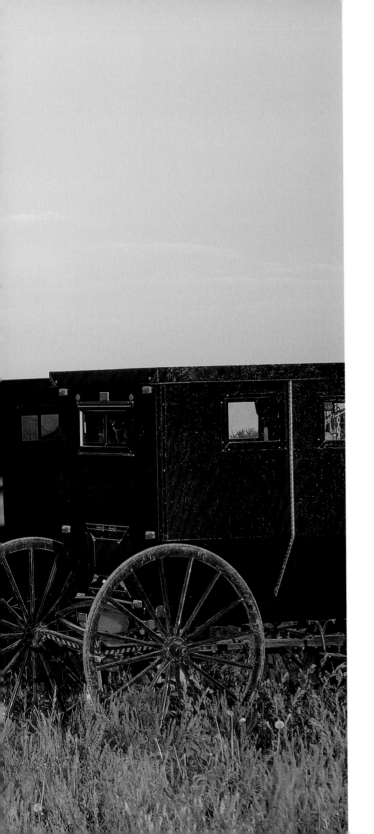

CONTENTS

FOREWORD

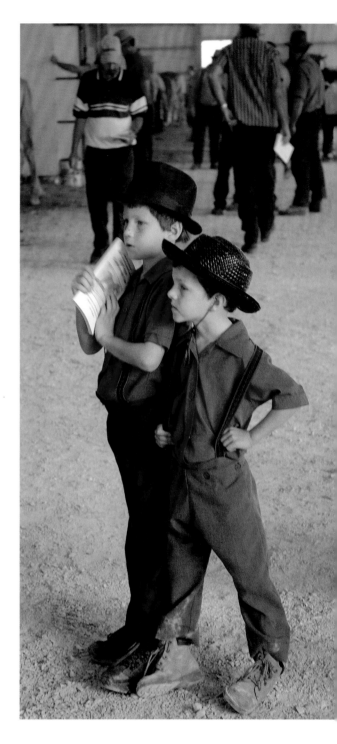

Today more than 30,000 Amish call Indiana home. Their horses and buggies, traditional dress, and modest schoolhouses mark the landscape in nineteen distinct settlements scattered from the border of Michigan to the Ohio River, and from the outskirts of Fort Wayne to north of Terre Haute. The largest and best known Hoosier Amish communities, attracting millions of tourists a year, are in the Elkhart-LaGrange and Nappanee areas of north-central Indiana. But other historic settlements exist near Kokomo and around the town of Berne in eastern Adams County, and newer settlements—some begun by recent Amish arrivals from other states—dot the state's southern tier.

Popular impressions notwithstanding, Indiana's Amish are not a uniform lot. For example—and as the photographs in this book attest—the horse-drawn carriages used in each community are distinct from those elsewhere. Some are enclosed but others are open to the elements, even in winter weather. Most buggies have windows and battery-powered lights, but among the most conservative groups the only lights come from modest lanterns hanging on the side of the carriage.

Variety among carriages is a symbolic but substantive indicator of deeper cultural differences. Indiana's Amish have different immigration histories, speak divergent dialects of German, and find employment in a range of workplaces. Although they all avoid the tyranny of technological determinism, they disagree on where to draw the line in

keeping innovation out of the home. Most forego private telephones, for instance, but a few small communities permit in-home phones and a scattered number of churches allow cell phones for busy contractors. Amish farmers in the Kokomo settlement till the soil with tractors, while those in all other parts of the state use horses.

Despite the diversity that exists among Indiana's Amish, there is a common core of faith and practice that unites them. All share four basic principles, which, taken together, represent a countercultural approach to life that the Amish and outside observers have dubbed Old Order. First, unlike most Americans, Old Order Amish do not emphasize individuality. The community is far more important than any individual Amish person. Second, Old Orders insist on tangible and visible means of separating their church from what they see as the corrupt world around it. Third, they believe that the church is their primary community, that it provides for the physical and spiritual needs of its members, and that they should not be dependent on institutions from the outside world. Finally, Old Orders view tradition not as a senseless burden to be cast off, but as a reliable guide in a volatile world. They face the future with confidence because they rely on the wisdom of past tradition.

Values and dispositions that flow from these core commitments shape the contours of Amish life everywhere. For example, distinctive clothing and horse-and-buggy transportation are symbols of separation from society. Most Amish people will readily accept a ride in a car, and even hire a driver for certain trips, but will not hold a driver's license because the car is linked to the modern age and worldly society has become dependent on the automobile. Then, too, automobile ownership would require the purchase of insurance and the Amish steadfastly refuse to entrust their care to a secular organization instead of the mutual aid that flows from the church. Moreover, the horse is part of well-established tradition that ties people to a local area, slows the pace of life, and requires little fuel. In addition, Old Order people are generally reluctant to talk about themselves or to describe the exemplary attributes of their children, viewing such expressions as individualistic pride. They eschew personal photography for the same reason, although some will, as evidenced here, permit a trusted outsider to take their pictures.

It is impossible to be Amish apart from a community. Unlike some religious traditions that prize individual spiritual experience, Old Orders do not believe they can find a solitary connection to the Divine. It is the local congregation—as many as fifty adults and eighty children—who establish and affirm a common set of understandings for going about life, from dress and deportment to the application of technology. They use the German word *Ordnung* (something like the English word *order*) to describe this common understanding. Ordnung governs all of life, and to transgress the Ordnung is to turn one's back on the community. Indeed, repeated rejection of the Ordnung can result in excommunication from the church.

Congregational leaders—a bishop, two ministers, and a deacon—guide local

church district life and oversee the Ordnung's persistent character and deliberate approach to change. Bishops preside over semiannual communion services, conduct baptisms, and perform weddings, while ministers take their turn preaching on Sunday mornings. Deacons keep tabs on the needs of members and collect funds to assist families with financial burdens they cannot bear alone—especially high medical bills.

Amish church districts gather biweekly for worship, always in the homes of members, and each household takes its turn in hosting a service. Old Orders do not have church buildings, which they believe send the misguided signal that the church is a place rather than a pilgrim people. Each three-hour worship service follows a similar pattern that includes sermons, scripture reading, prayers, and singing from the oldest Protestant hymnal in continuous use, the Ausbund. Singing these slow-cadence German hymns, first composed by spiritual ancestors awaiting execution hundreds of years ago, reinforces for contemporary Amish a sense of connection to the past and a countercultural commitment to tradition in the midst of a modern society built on speed and dedicated to the next new thing.

Although today deeply embedded in the Hoosier countryside, the Amish story began far from the valleys of the Wabash and Saint Joseph Rivers. In the midst of sixteenth-century Europe's religious ferment—a tumultuous period that birthed the Protestant Reformation—a movement emerged that combined a notion of voluntary church membership (in contrast to state-church synthesis) with a commitment to strict moral discipline. The adherents' sense that the true church was to be apart from, rather than a part of, larger society—along with their pacifism and their withdrawal from what they considered "worldly" society—earned them animosity from mainstream political and religious authorities. Memories of European persecution and harassment, kept alive in contemporary Amish sermons and in the thick *Martyrs' Mirror* book, continue to foster a sense that the world cannot fully be trusted. In time, one wing of the movement, eventually known as Mennonites, adopted a more accommodating approach to surrounding society. But followers of Jakob Ammann—the Amish—called for continued vigilance in monitoring the boundary between the church and the world.

In the 1700s and 1800s Amish households left Europe for North America, and arrived in Indiana after 1840 by two different paths. One stream was made up of descendants of families who had arrived in Pennsylvania generations earlier and who now were pressing westward with other white settlers in search of additional acres. Fresh European Amish immigrants moving directly to the Great Lakes and Mississippi Valley regions comprised the other stream. These twin migration paths produced some of the historic and ethnic diversity that still marks the state's Old Order population.

The large Amish communities in Elkhart, LaGrange and adjacent counties, along with the settlement near Kokomo, sprang from migrating Pennsylvania households

and speak a German dialect known as Pennsylvania Dutch. In contrast, most of the Amish who took up farms in Allen and Adams Counties on Indiana's northeastern edge haled directly from Europe. Known as Swiss Amish, these latter folks spoke a decidedly different dialect and otherwise carried cultural customs that set them apart from their Pennsylvania Dutch religious kin. One of the easily recognizable differences between the two Amish ethnic groups is the Swiss practice of driving unenclosed buggies. Pennsylvania Dutch Amish traditionally drive enclosed buggies.

Not all differences are so easily discerned. For example, the Daviess County Amish community—which figures prominently in this book's photography—began in 1869 as a Swiss settlement with links to Allen County Old Orders. But a century and a half of cultural evolution, along with the influence of migration to and from other Amish centers, has produced a population that represents a mix of both ethnic streams: Swiss surnames and dress patterns combine with a Pennsylvania Dutch dialect and enclosed buggies. Family ties to Allen County are still prominent, but so, too, are links to other places in Indiana, Missouri, Ontario, and elsewhere. In that sense, the Daviess Amish embody the interplay of enduring tradition and gradual change that mark all aspects of Amish life.

In addition to the church, the most important group of people in any Amish person's life is family—and family and church are connected in many ways. For example, although marriages are not arranged, the choice of partners is limited. Amish church members may only marry other church members and young adults seek the approval of parents and church leaders before proposing matrimony. Weddings are typically held on a weekday at the bride's home. The service follows the typical format of a church service with the actual wedding ceremony added at the end. The rest of the day is given to eating and visiting among the hundreds of family members and friends in attendance.

Marriage and childrearing are expected in Amish society, and single adults or childless couples enjoy somewhat lower social status. Marriage is taken very seriously and the marital vow is not easily broken. Divorce is extremely rare, and individuals are never free to remarry until their spouse has died.

Many Amish households have seven or more children. Birth takes place in the home, or less often at a hospital. In LaGrange County, rural birthing centers offer another option. Infants are given a great deal of attention in Amish families. However, once a child becomes self-aware, parents begin a careful molding process with the intent of shaping the child for a life of submission to the church as an adult. Parents do not hesitate to use corporal punishment, although the more pervasive parental influence is simply the example modeled in how to lead a Christian life.

Amish schools play an important role in socializing children into an Old Order way of life. Most Hoosier Amish children attend private schools. Some parents in the state's older settlements, where Amish and administrators have built up generations of

good rapport, send their children to public schools. But even in these places a growing majority of students enroll in parochial schools—and they do so exclusively in newer settlements where parents have no longstanding ties to local public education. Children begin school at age 6 or 7 and continue only through eighth grade (even if they are attending public school). An Amish person who continues through higher education does not remain within the church.

The first Amish school in Indiana opened in 1948, although the rise of such schools did not begin until the late 1960s when consolidation of rural public schools pushed parents to consider other options. Amish schools are typically one- or two-room buildings with multiple grades in a single room. Amish teachers, usually young women who are themselves graduates of an eighth-grade education, conduct classes in reading, writing, mathematics, and geography. Lessons are taught in English even though German dialect is the spoken language in the home. Some children learn English for the first time when they enter school. Recess provides opportunity for rigorous exercise, often including team sports such as softball, although new teams are composed each day so as to avoid the formation of ongoing competition. In school, as in other areas of Amish life, cooperation and sharing supersede acknowledgment of individual accomplishment.

An Amish child's life is carefully controlled until age 16. At that point parents typically allow more latitude. Young people may begin living somewhat differently from their parents as they size up the decision of whether or not to join the church. A boy may choose to dress in non-Amish clothes, or a girl may begin regularly watching television at a non-Amish house she cleans as a part-time job. For many Amish teens, these years are relatively quiet even if their choices temporarily diverge from that of their upbringing. For others, experimentation with the world may involve deviant behavior that draws public attention and brings shame on their parents.

Despite their toying with worldly ways, nearly 90 percent of children join the Amish church through baptism, most often in their late teens or early twenties. Old Orders believe that only an adult can make an informed decision about becoming a church member. The commitment involved is serious and an Amish young person does not take it lightly. Members are subject to church discipline and must submit to the Ordnung of their church district. In some Indiana communities a baptized member who leaves the church will be shunned (avoided in certain symbolic social ways) by other Amish for life.

As Amish people age, they can count on being cared for by their adult children. Extended family and fellow church members will cover their medical costs. Although occasionally an Amish person can be found in a retirement center (often if extreme disability makes homecare impractical), almost all live with or next door to a son or daughter and are integrated into a multigenerational family.

Amid the persistent patterns of Indiana Amish life, there are subtle but significant

changes. One of the most far-reaching in recent years has been the decline in farming as a way of making a living. Until a few generations ago, tilling the soil was the nearly universal vocation of Old Order families. Now, however, with a few exceptions, farming is no longer the norm. The reasons for the shift are many, and include the rising price of farmland, the challenge of turning a profit on the small scale that Amish farmers prefer, and the relative ease with which one can land an off-farm job.

In the large Nappanee and Elkhart-LaGrange settlements, the most common employment avenue for Amish men has been work in one of the area's many recreational vehicle and manufactured-housing factories. In some other communities, including those in Allen and Adams Counties, and the settlements in Daviess County and near Milroy, the occupational alternative has been construction work. Amish carpenters in these places work locally or travel as far as 200 miles in contractor-provided vans to jobs in Indianapolis, Cincinnati, or Louisville. A third strategy for making a living has been Amish-owned small businesses specializing in everything from furniture making to welding shops to commercial retail. Such firms keep work near home and offer the possibility of engaging several generations in common tasks, much as farming did. But they also risk the potential of inviting innovation, such as taking telephone orders, into the very heart of family life.

Fewer and fewer Amish families make their living from full-time farming—less than 20 percent in most of the larger communities—yet the decline of Amish agriculture has not meant a loss of the rural ideal or the rural setting of most homes and families, as the photos in this book attest. Indeed, some Amish from more populated parts of the United States have moved to Indiana in recent years, establishing new settlements in less congested Hoosier counties. Pennsylvania Amish who moved to Parke and Wayne Counties in the 1990s are one such example. Their characteristic gray buggies, in contrast to the black carriages otherwise found in the Midwest, now travel Indiana back roads, adding another piece to the state's Amish pattern.

The search for rural residences is only one of the challenges today's Amish face, fueled by suburbanization and their own population growth stemming from large families and high retention rates. Occasional conflicts with state government grab headlines, although the history of Amish relations with Indianapolis has been fairly amiable. Attention from the outside world and the rise of tourism have also impinged on Amish society in some parts of the state, but show no signs of undercutting it. To the contrary: Amish life in Indiana is thriving. No people's future is certain, but Indiana's Old Orders are at home here, living plainly and serving God.

Thomas J. Meyers and Steven M. Nolt
Goshen College
Goshen, Indiana

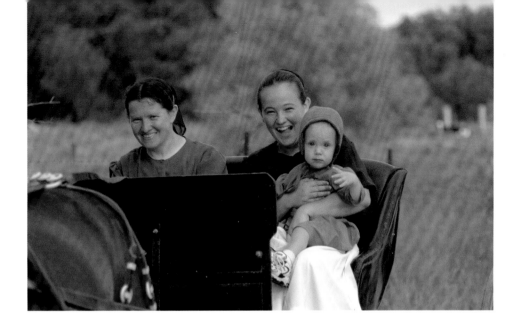

PREFACE

While growing up in Auburn and Fort Wayne I frequently encountered Amish families in their buggies on the back roads of northeastern Indiana. It was always a curious sight for me as a child to ride in a car with my family and to pass by another family who was riding in a horse-drawn buggy. I would look in amazement at this family who was living in a totally different manner, and I would wonder why they were living this way. I admired them for doing without all those things that I took for granted—electricity, cars, and all the rest. When I took Drivers' Education classes my instructor had me drive to the towns of Harlan and Grabill and the surrounding countryside. This was truly Amish country, and I enjoyed these drives so much that when I had my driver's license I continued to drive through these communities on my own, just so I could see the farms and Amish families.

When I began my first photographic book on Indiana, I wanted it to be representative of all that one would find in our state. I returned to Harlan and Grabill in order to take pictures of the Amish. I walked up to the homes and spoke to the families about my project and asked permission to photograph them and their farms. I knew that it was not their custom to permit photographic images to be made of them, and I did not want to offend anyone. The first Amish man gave me the advice that was to become my practice: they would not pose for a portrait, but I could take all the photographs I wanted while they were working. Another Amish farmer confirmed this

for me in an interesting way. I had pulled to the side of the road and used a telephoto lens to photograph a man with a team of six horses. Soon the farmer came to the fence near me and stopped. I thought that he was annoyed with me, so I was ready to apologize. Instead of being angry he wanted to help me; he was ready to add four more horses, so if I came back in an hour I could get a better picture!

Several years later the Indiana State Museum planned an exhibit of Amish quilts. The curators asked me to make two 360-degree panoramic photographs of the Amish countryside in order to give a "sense of place" for the viewers. One curator suggested specific county roads southwest of Shipshewana. I drove for miles in the "Amish Country" of Nappanee, Goshen, Middlebury, Shipshewana, and Ligonier and became well acquainted with its back roads and Amish farms.

While working on a book about Indiana corn, I was able to spend a day during harvest season with an English (non-Amish) farmer as he drove his combine on his 1,500 acres of corn (he also had 1,500 acres of soybeans). We were about the same age, and he spoke about growing up in the 1950s and the way life was on the farm then compared to now. He regretted most the loss of the farming community and the family farm. When he was young they tilled about 500 acres, and all around their farm were other farms of about the same size. Families worked together on those farms and they had a bond with others in the community. But now, the farmers had to sell their land and work in the cities. In order to survive he had to farm more and more acreage. His 3,000 acres would have allowed six or more families to live off the land.

The next day I drove to the Amish area of Daviess County, between Odon and Montgomery. I stopped at a farm where I saw corn shocks in the fields and spoke to an Amish woman, to request permission to photograph the farm. As I stood in the field and looked all around me, I counted eighteen separate farms, and knew that families worked together on them. This is what the English farmer was missing! The Amish were maintaining a traditional family-oriented way of life, a community of people who help each other at planting and harvest times. They work together and they pray together. It is a difficult life, but they choose to live in this manner, and they are grateful to God for this opportunity. They intentionally live plainly and simply, though allowing for various accommodations with the modern world.

I live with my wife and children in Owen County where there is a growing community of Amish families in the Freedom/Worthington area. I have come to know many of the families and have great respect for them. I have had discussions with the farrier John Lehman and the minister Freeman Yoder and his wife, Mabel. I am grateful to them for opening up the meaning of the Amish community, welcoming me and encouraging me in this current project. I hope that the images in this book will be considered a tribute to all the Amish in Indiana.

Darryl Jones
January 20, 2005

Amish Life

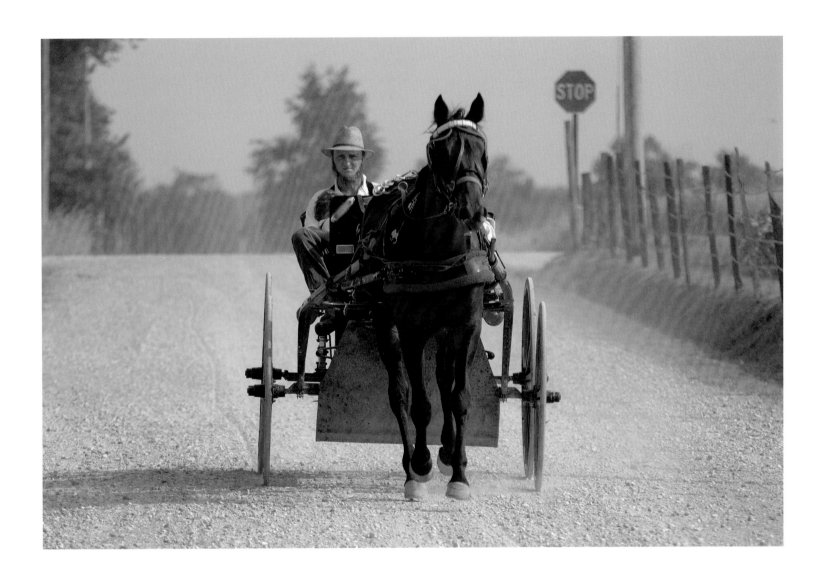

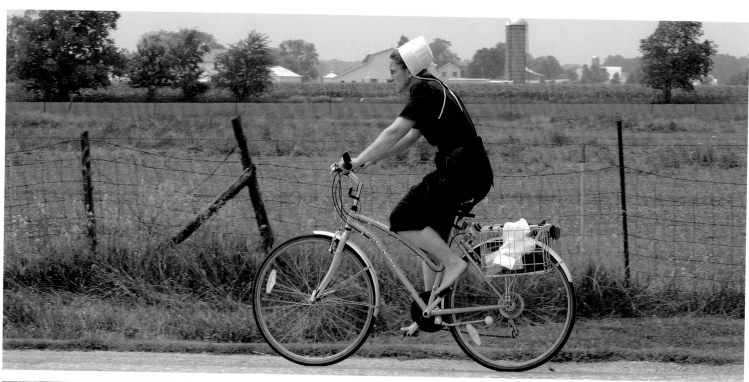

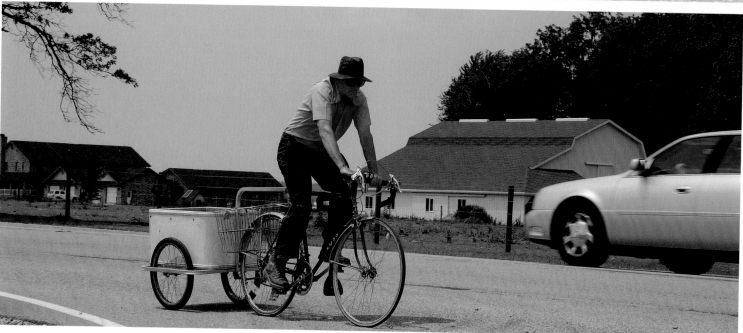

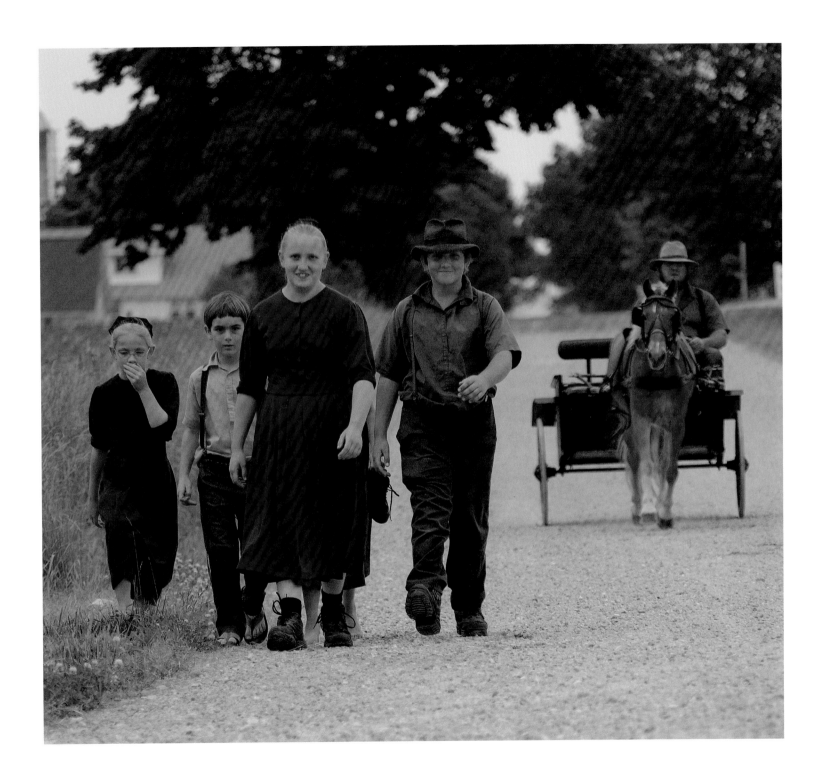

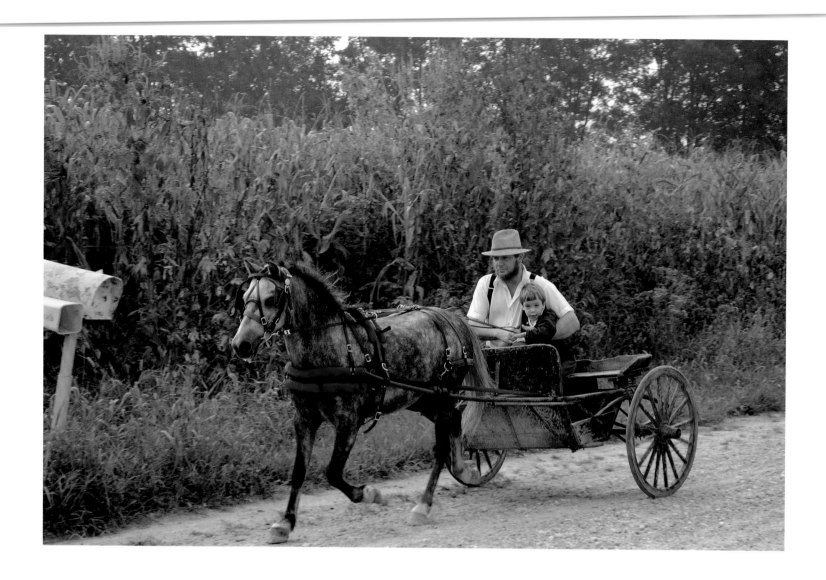

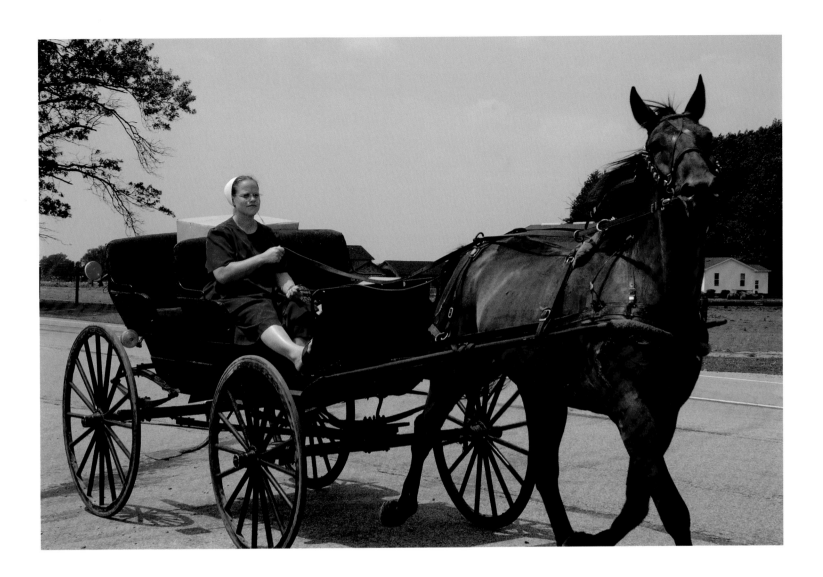

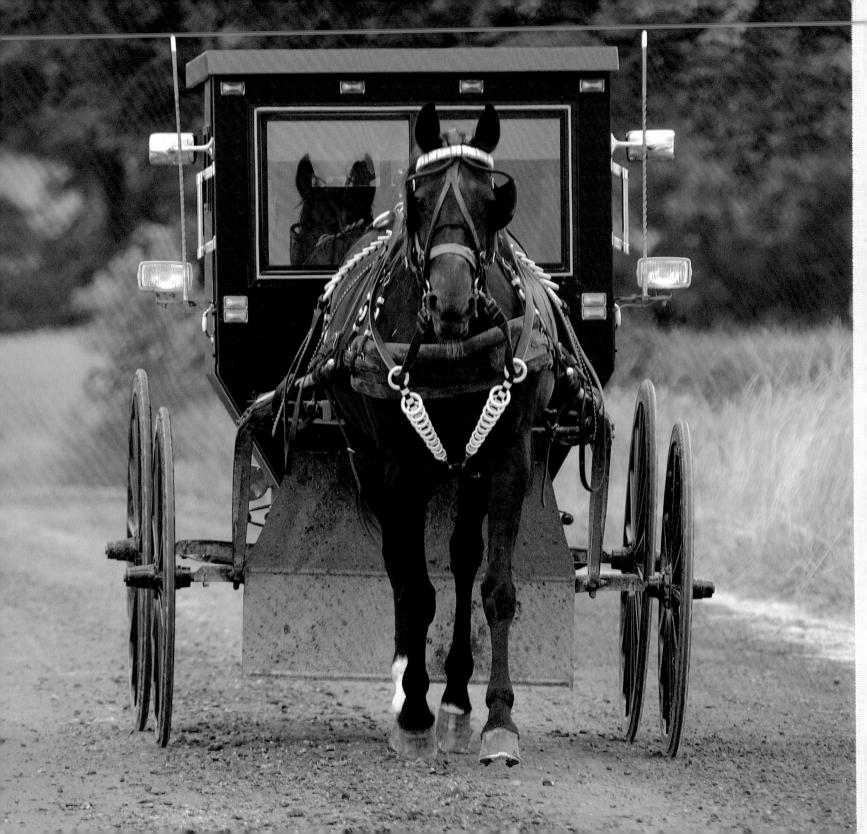

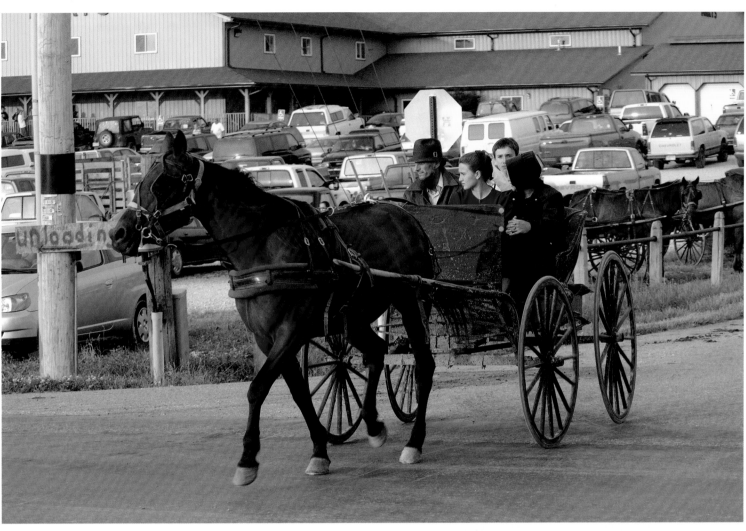

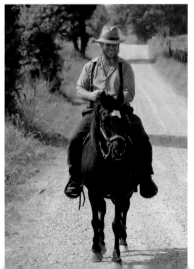

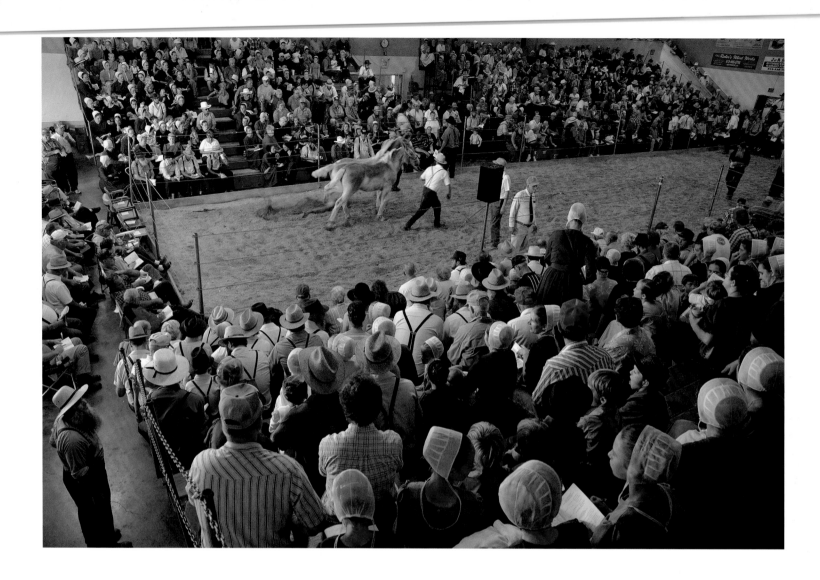

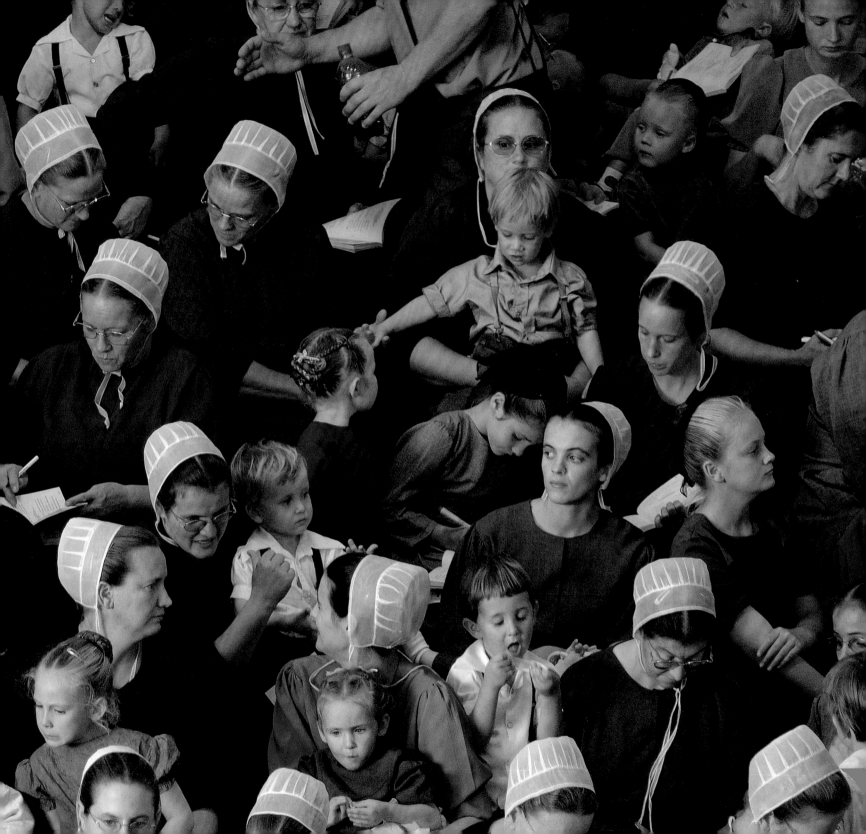

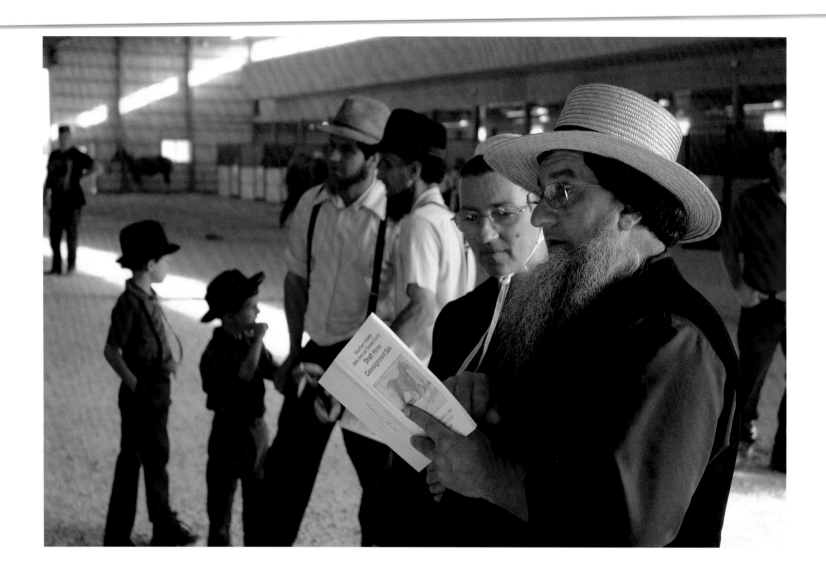

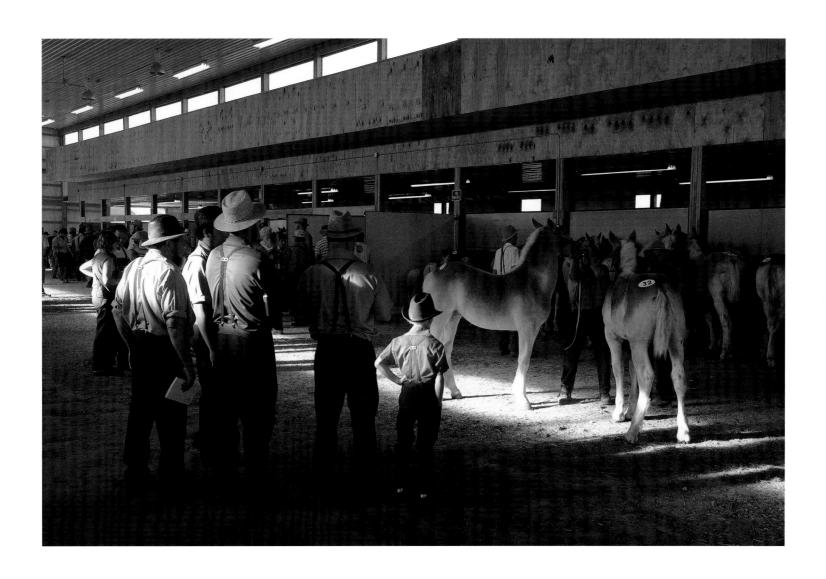

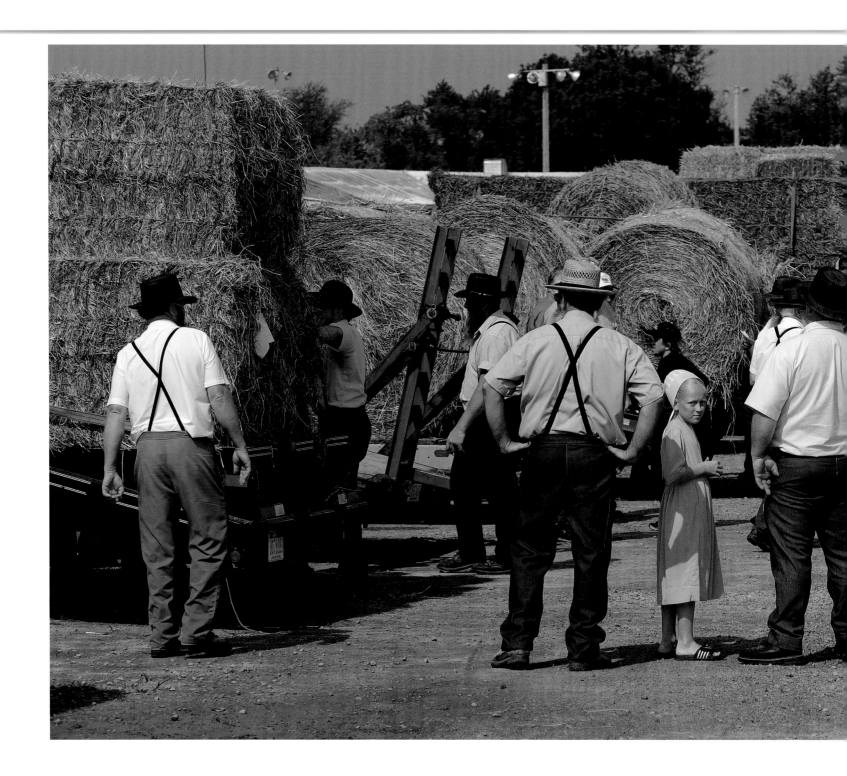

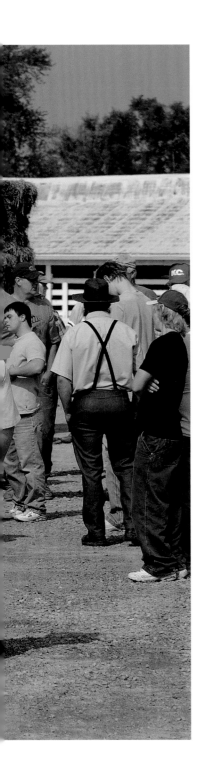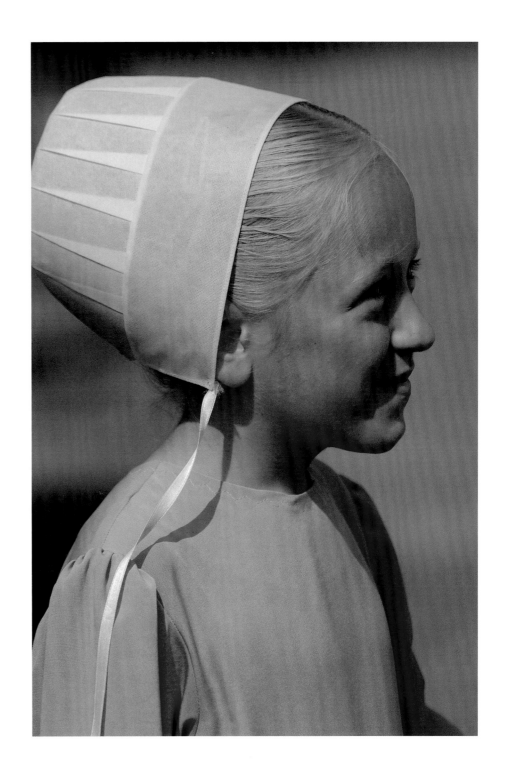

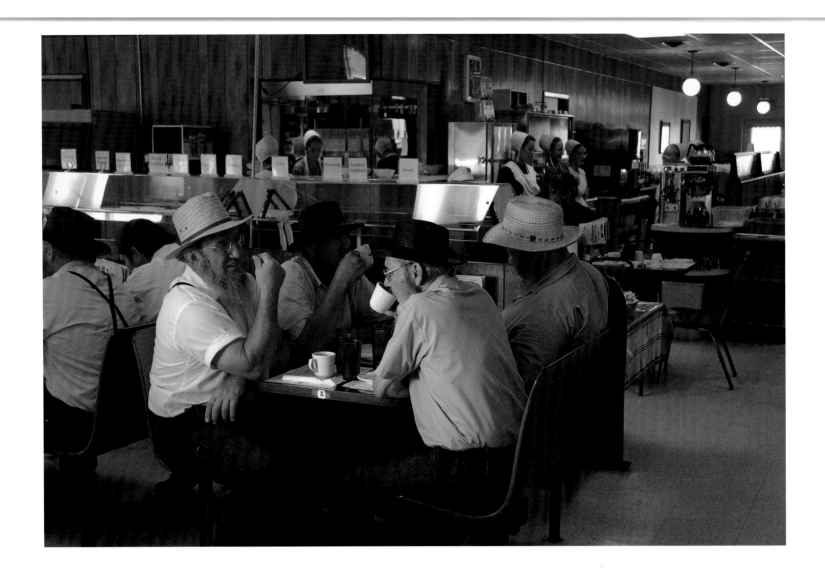

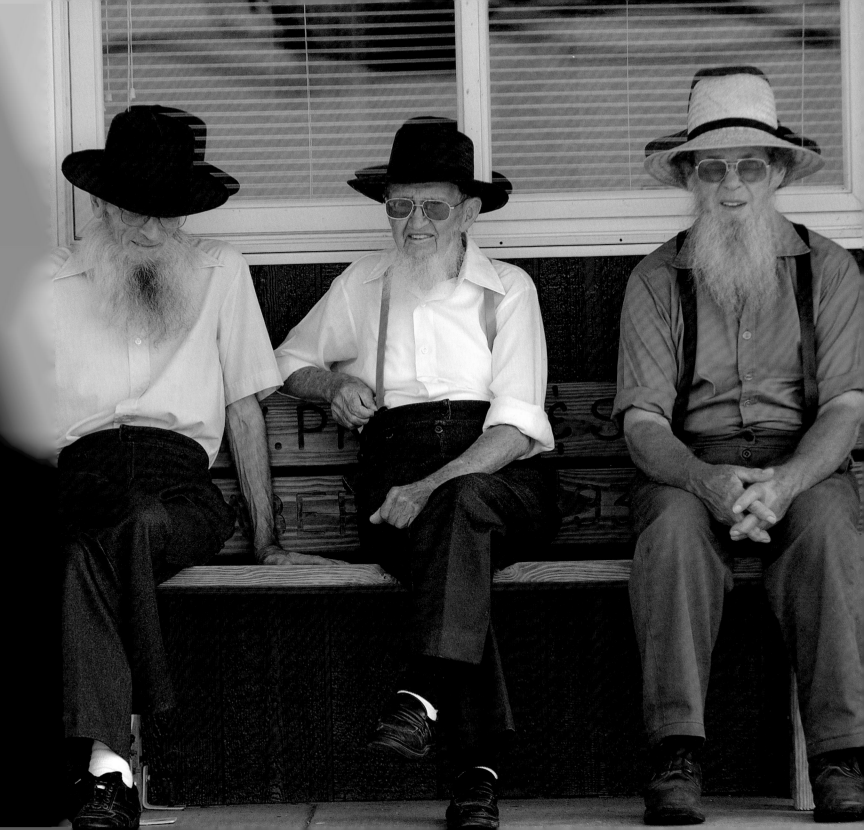

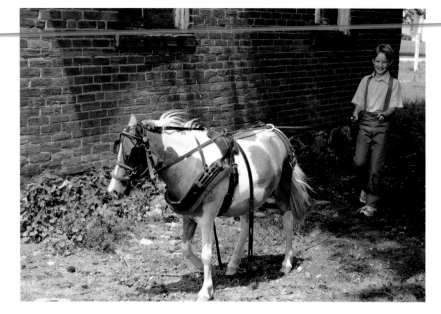
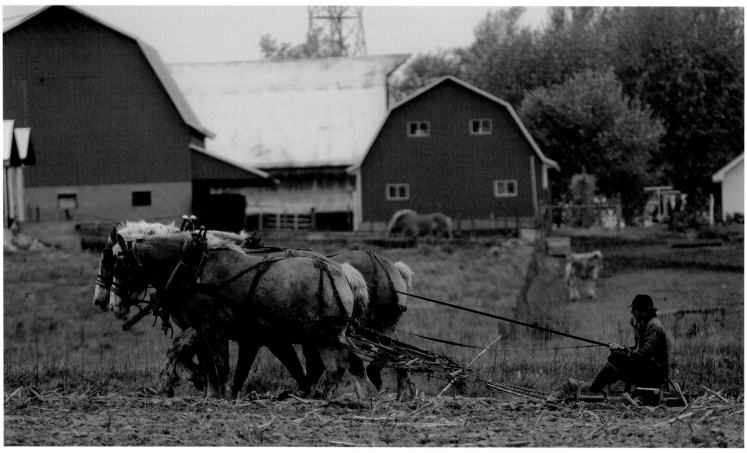

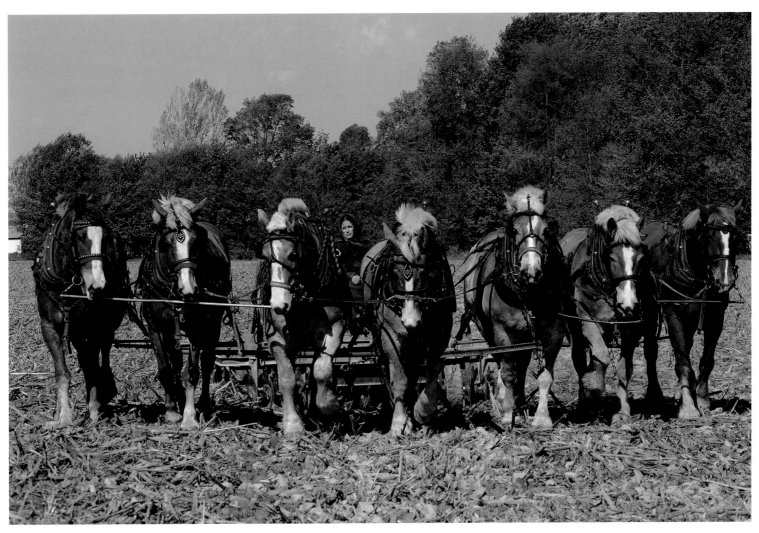

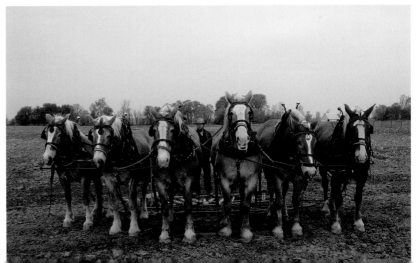

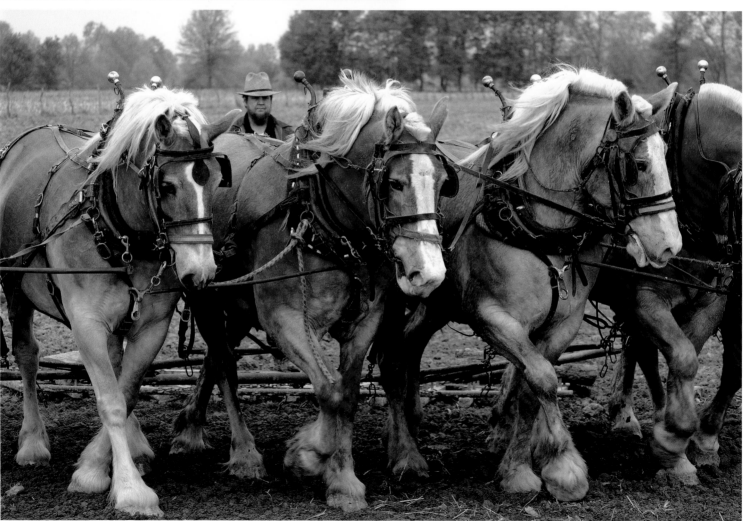

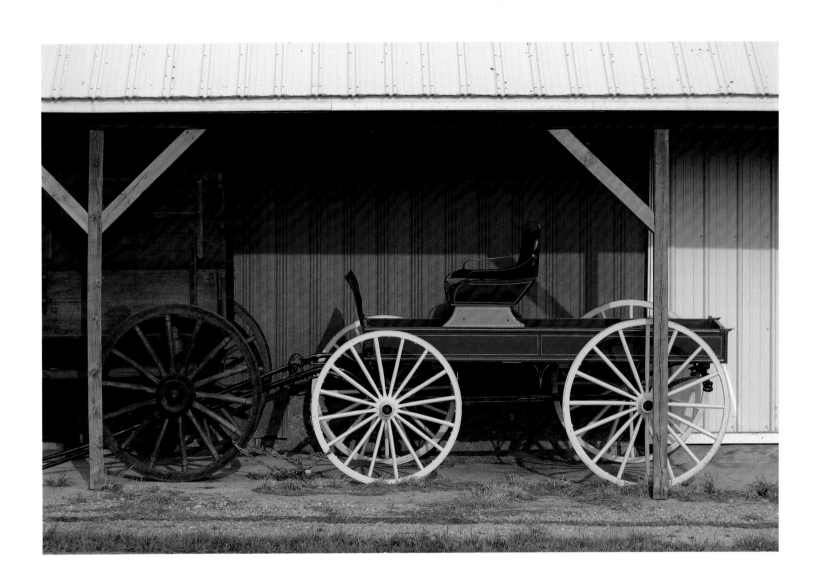

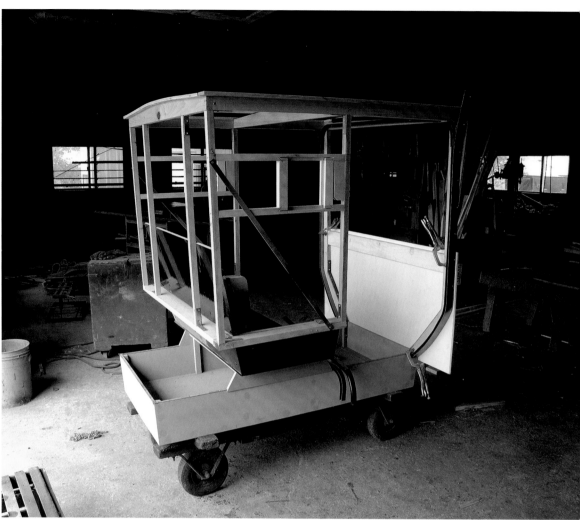

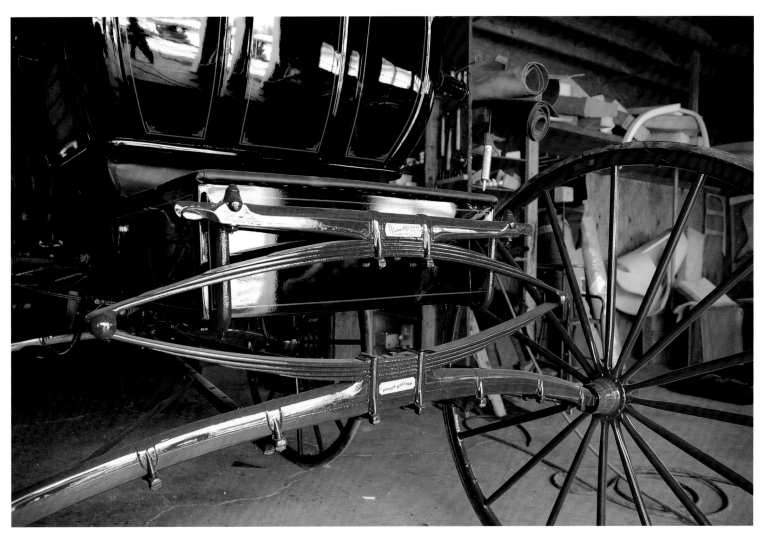

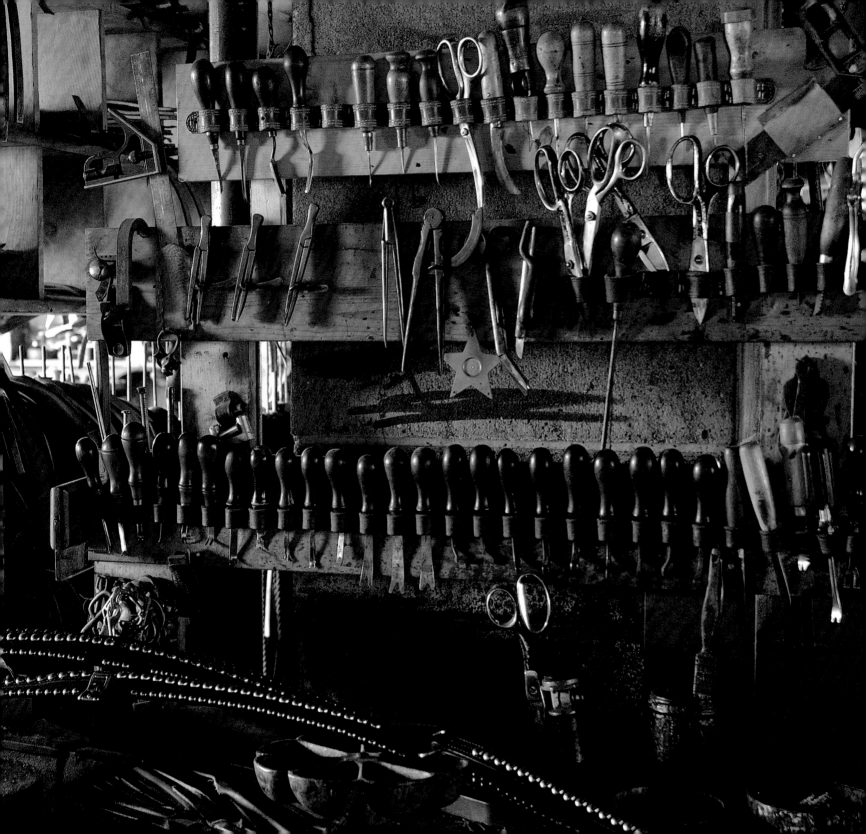

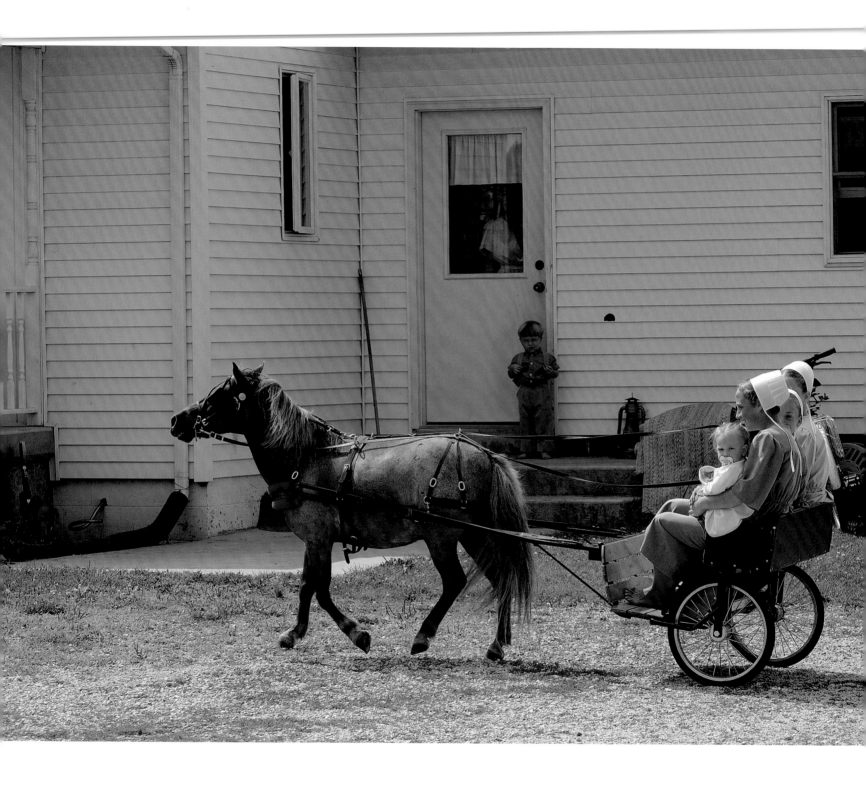

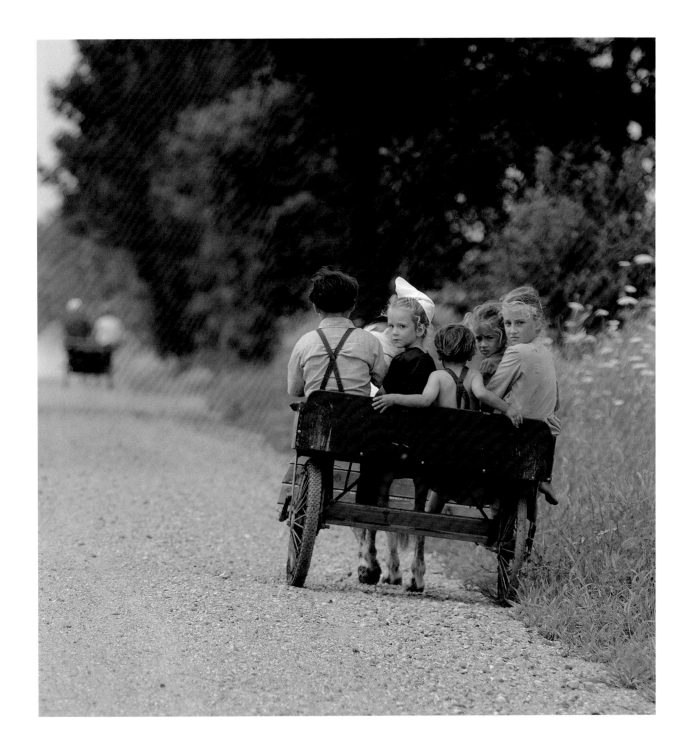

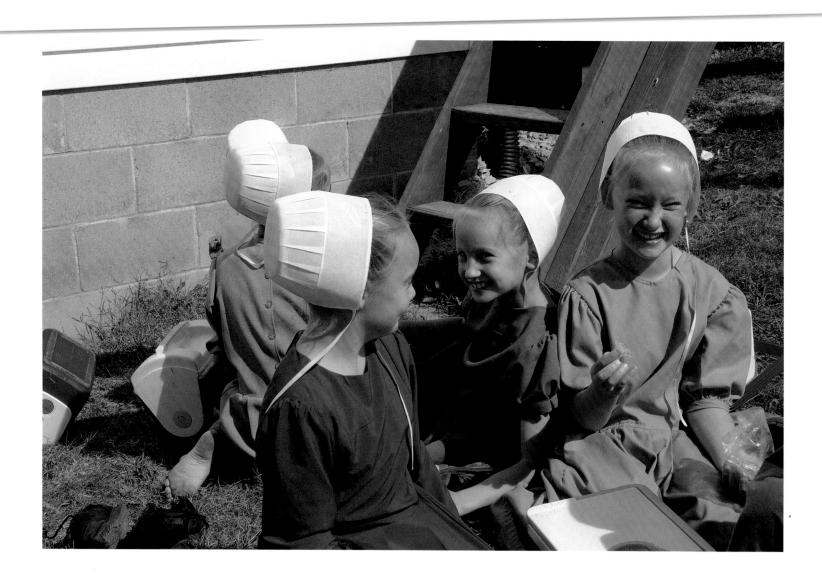

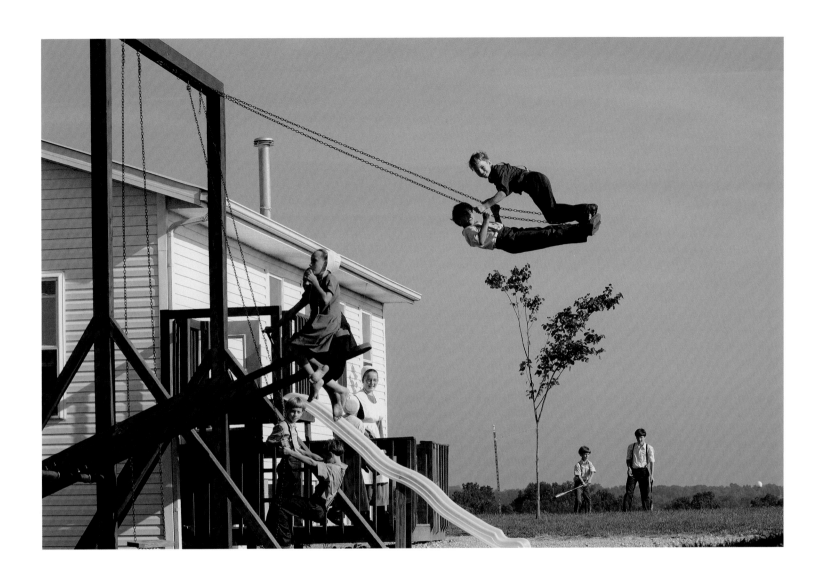

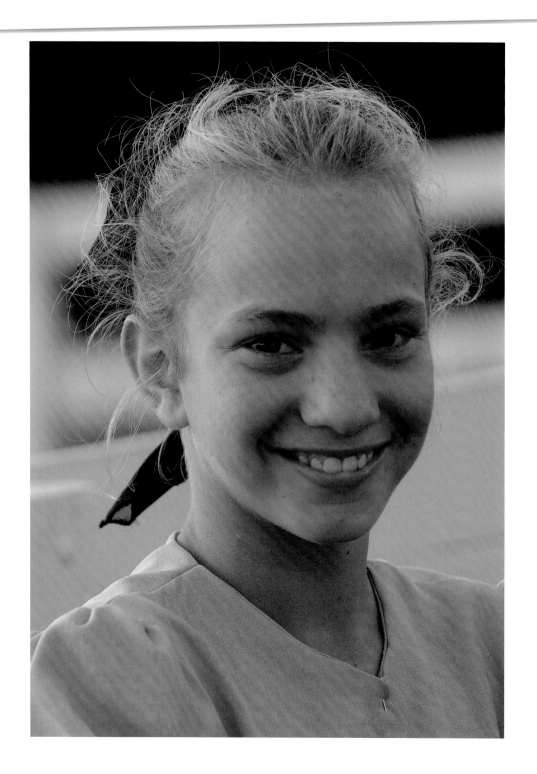

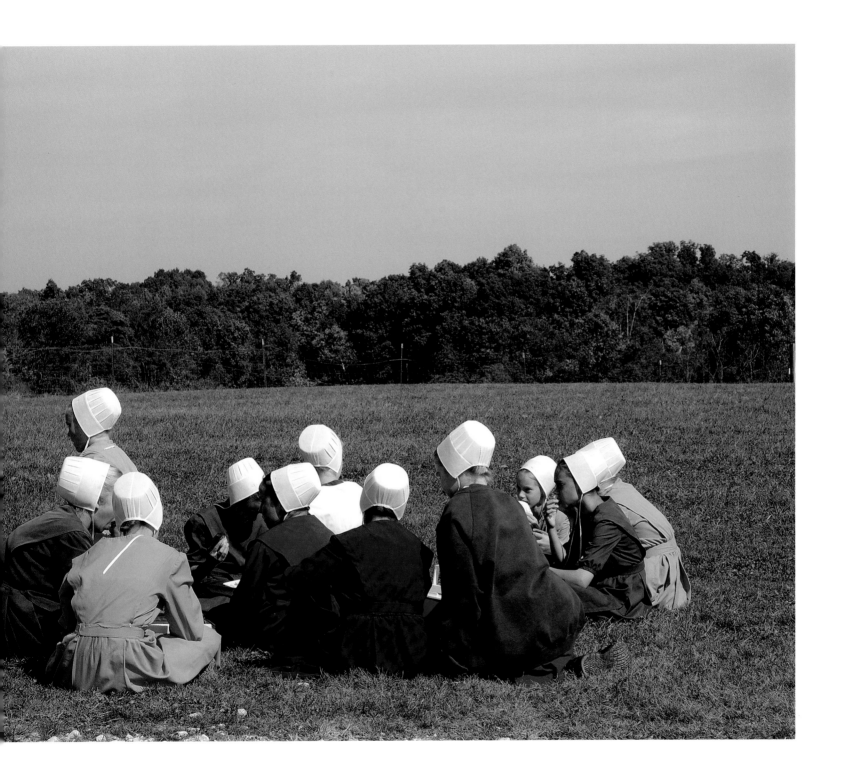

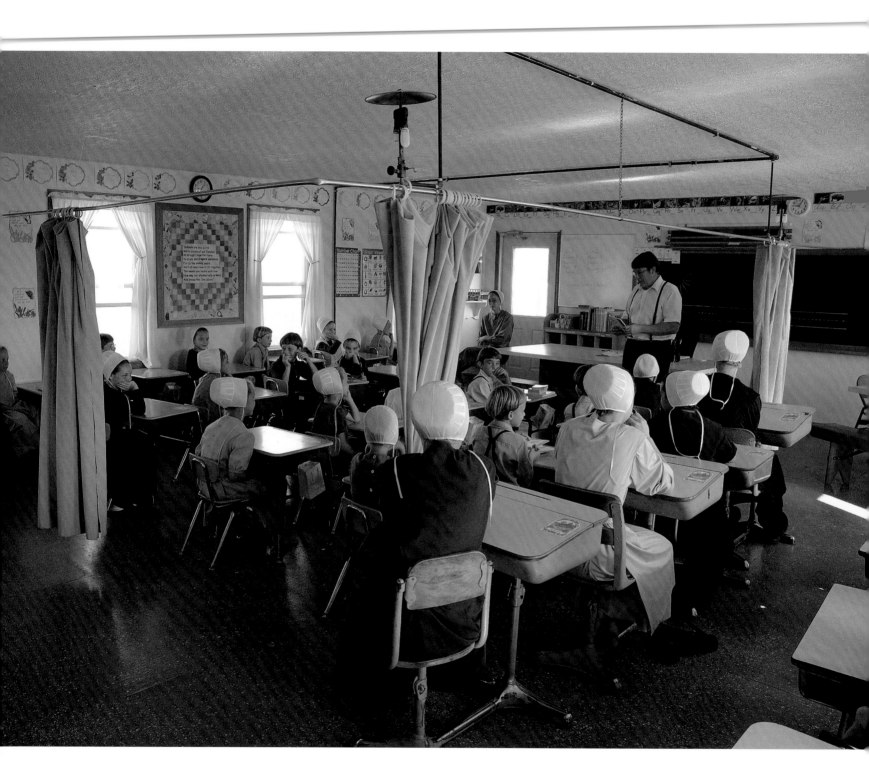

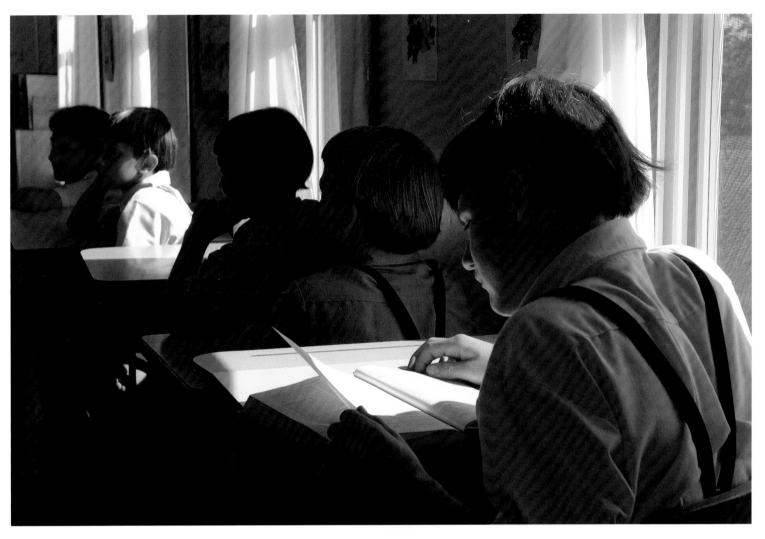

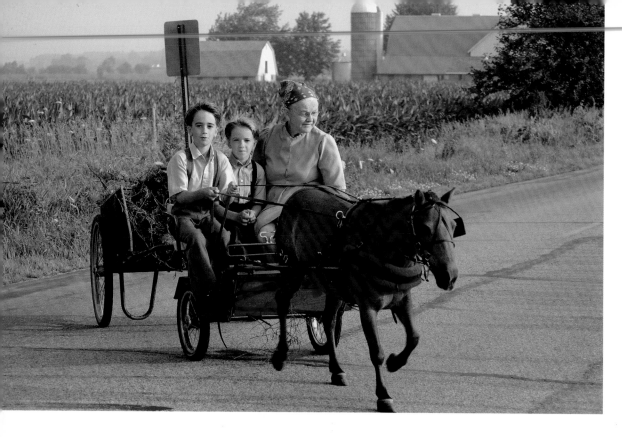

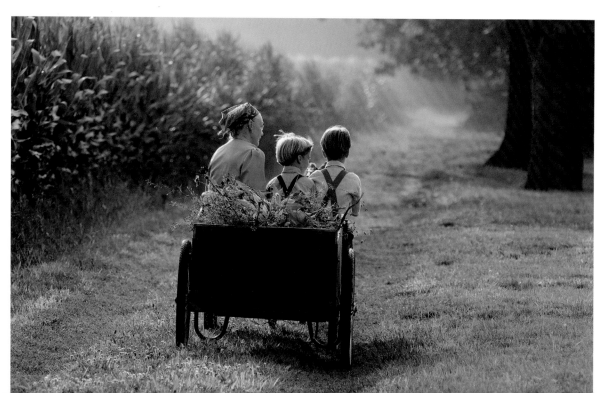

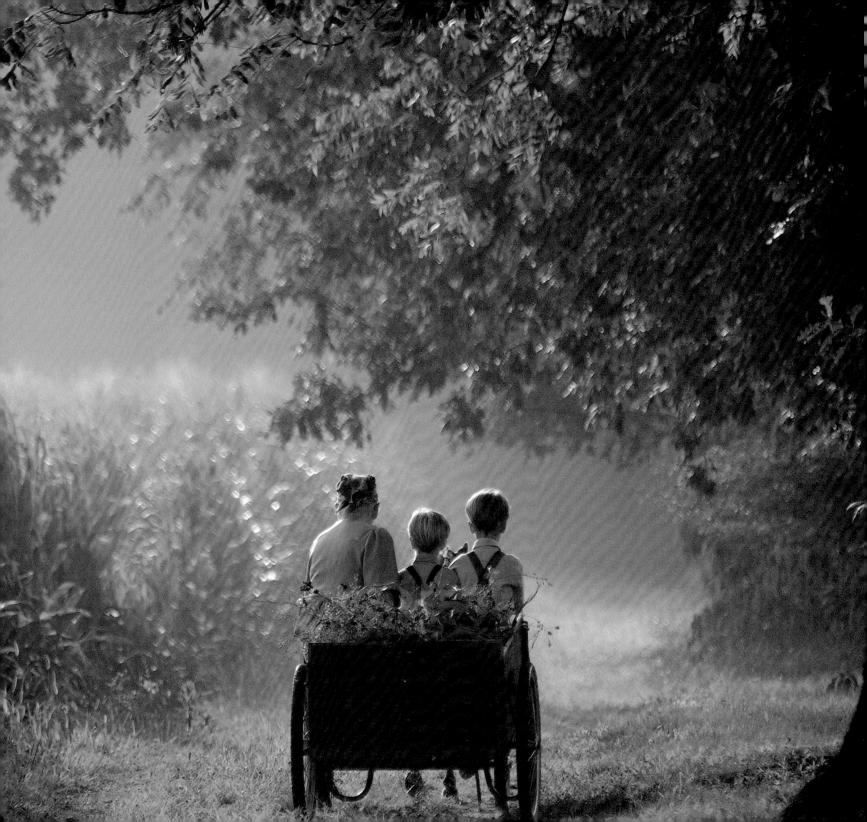

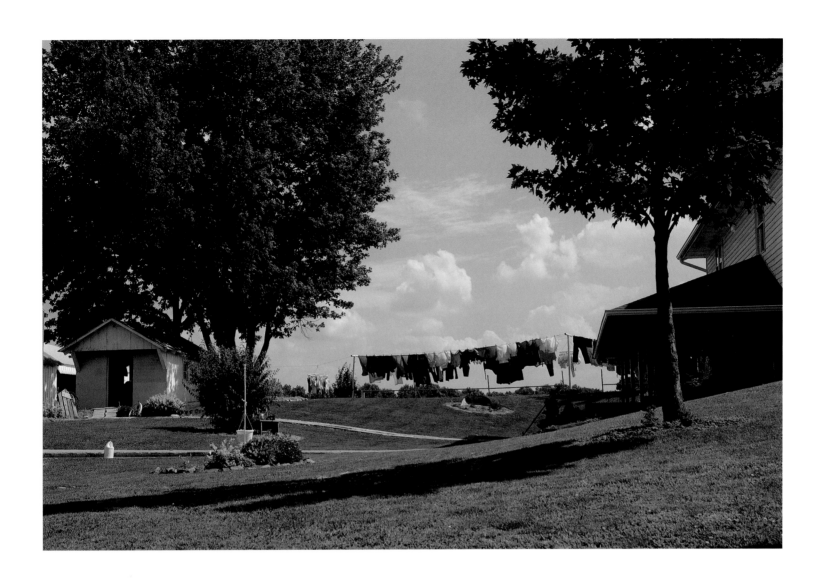

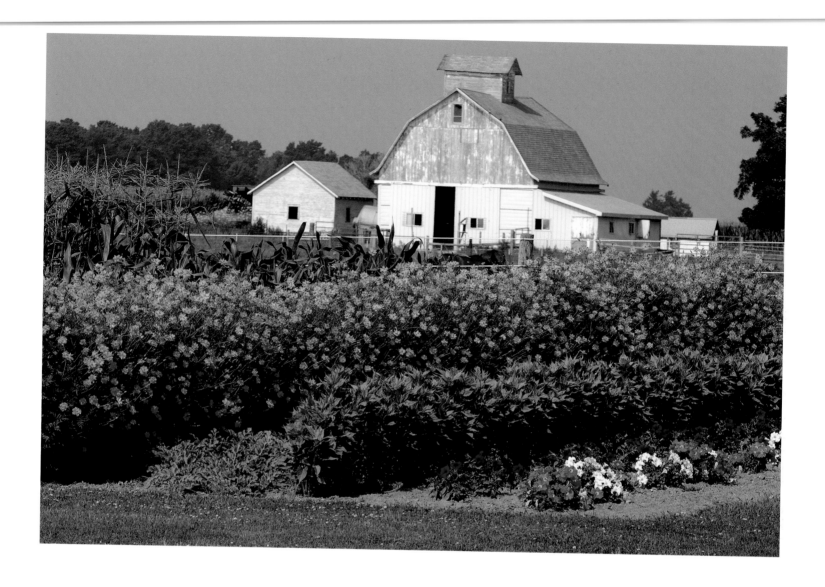

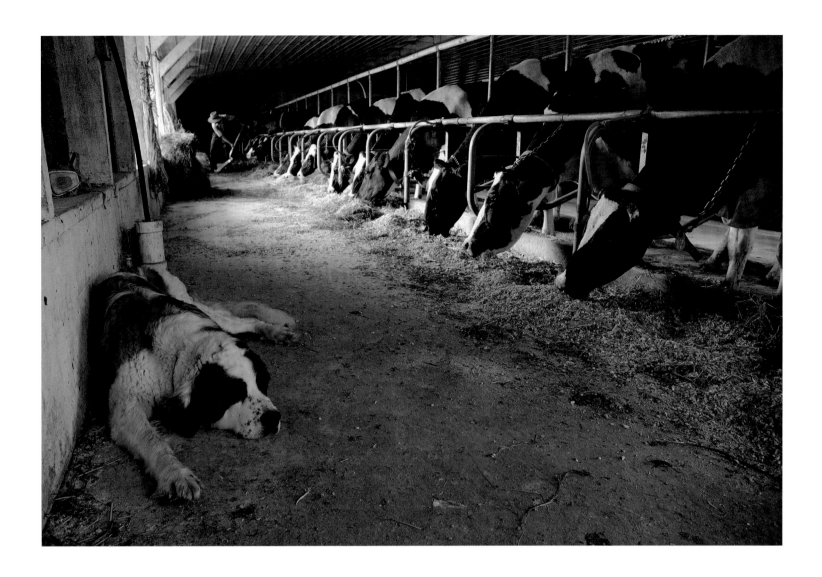

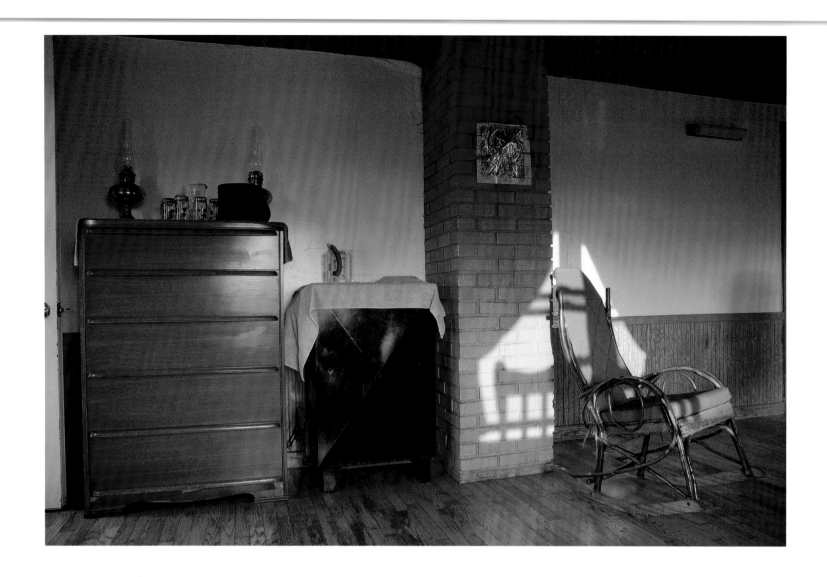

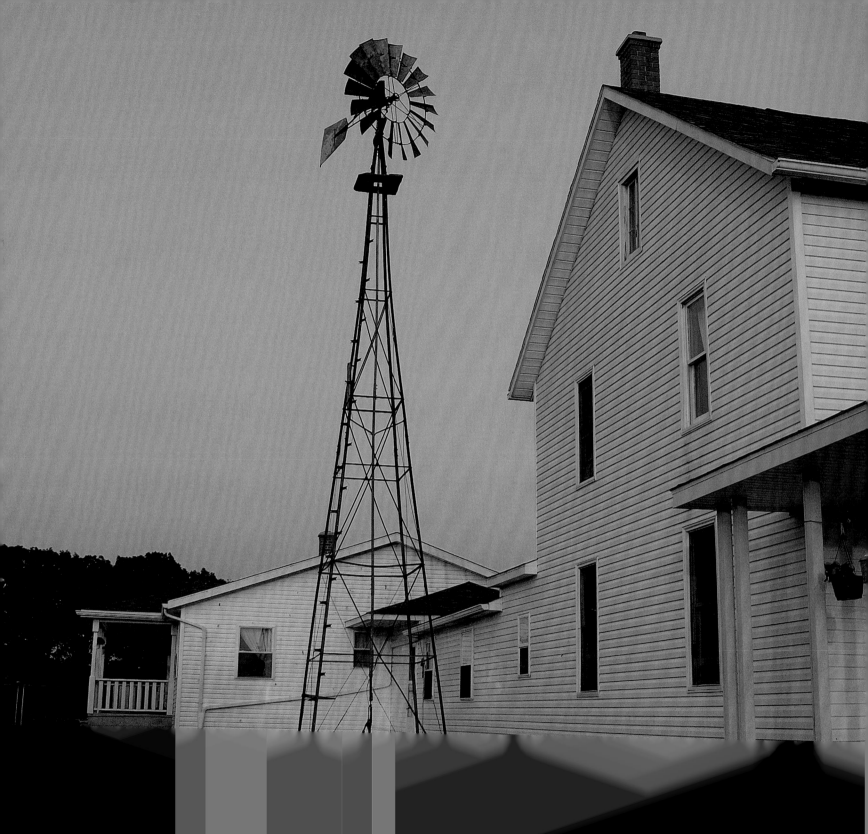

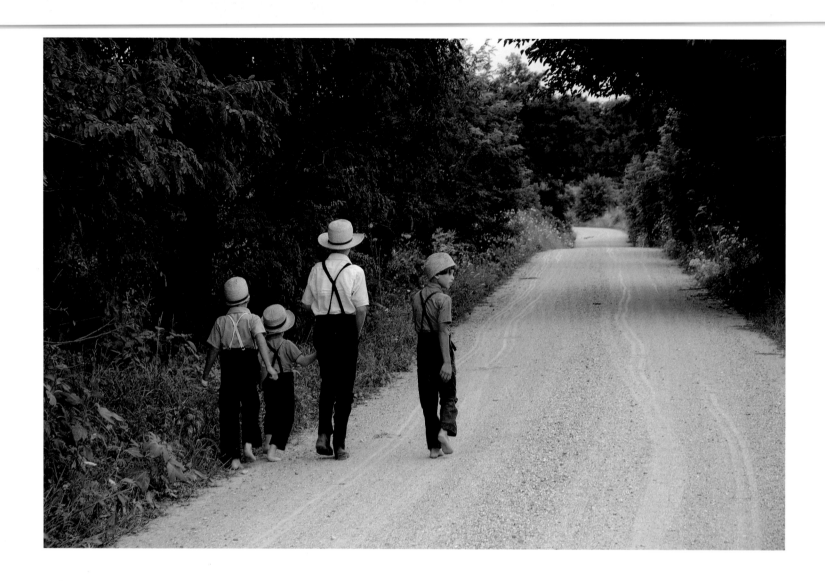

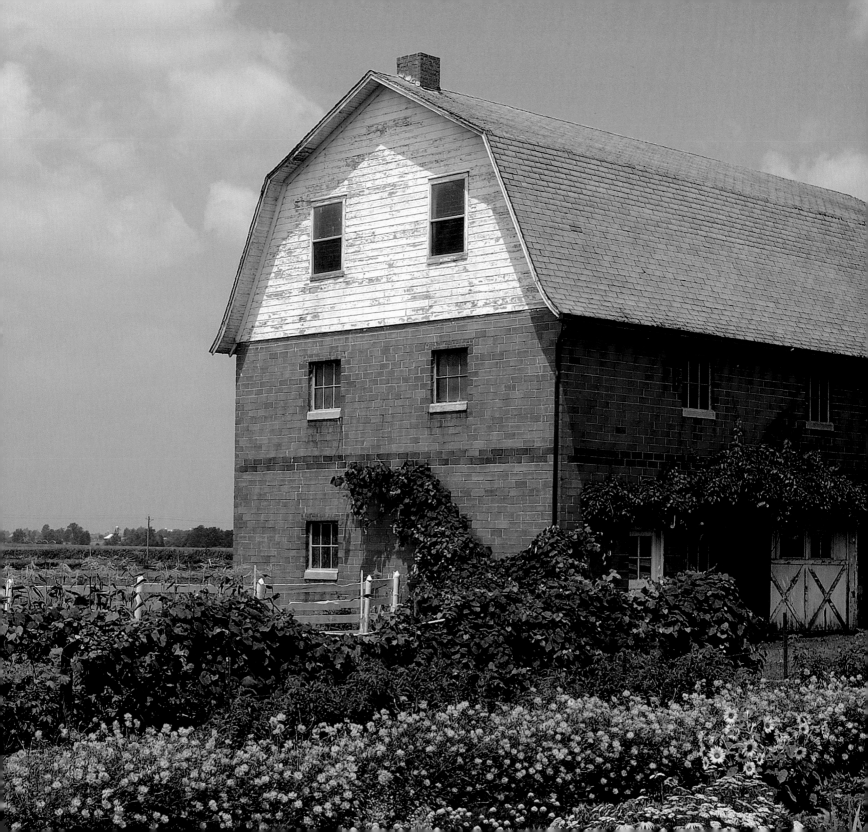

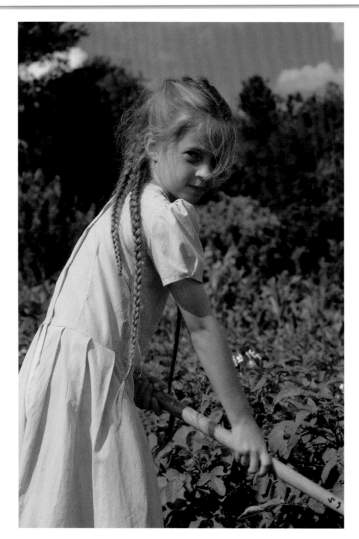
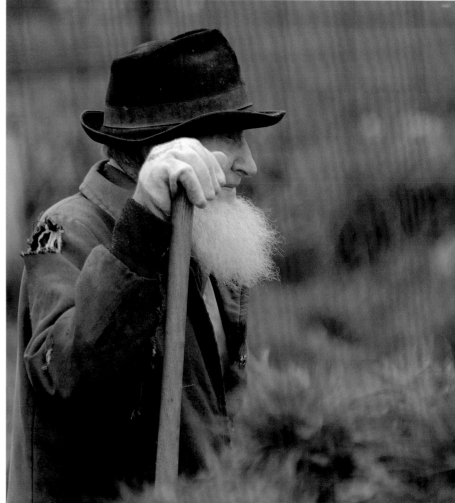

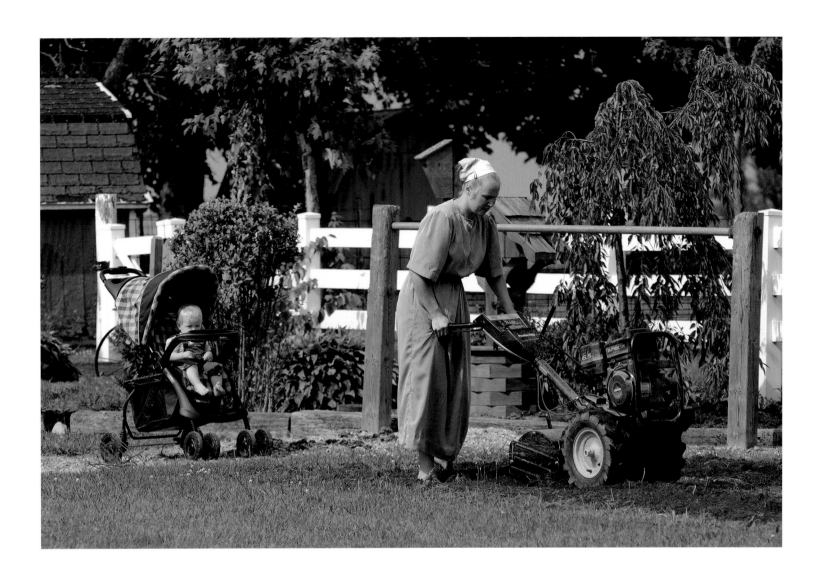

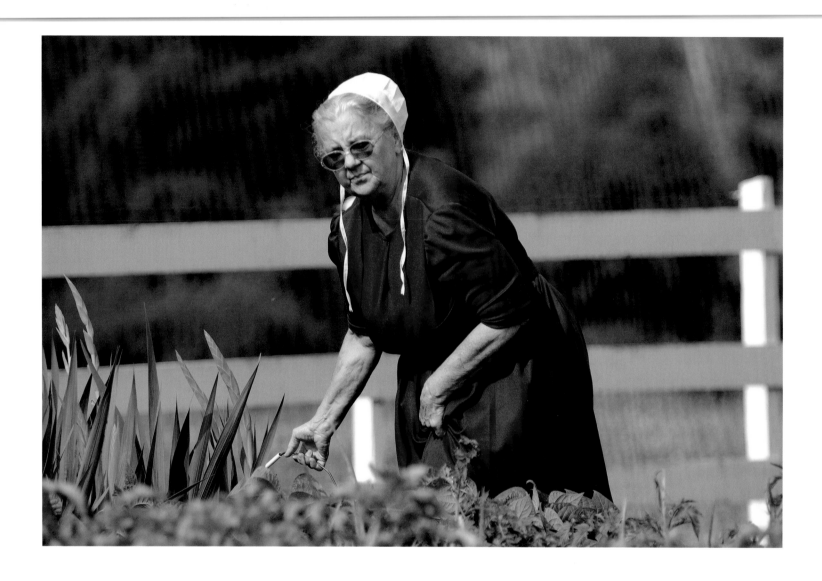

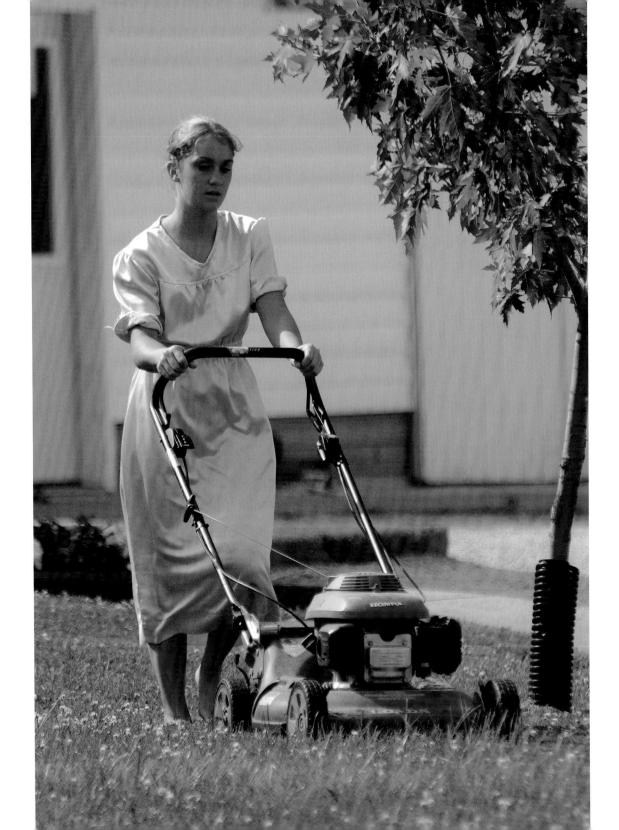

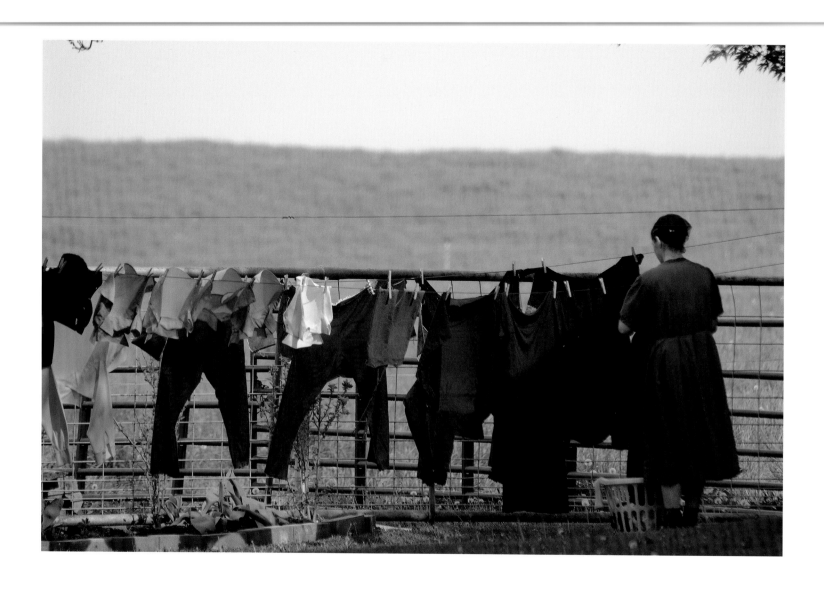

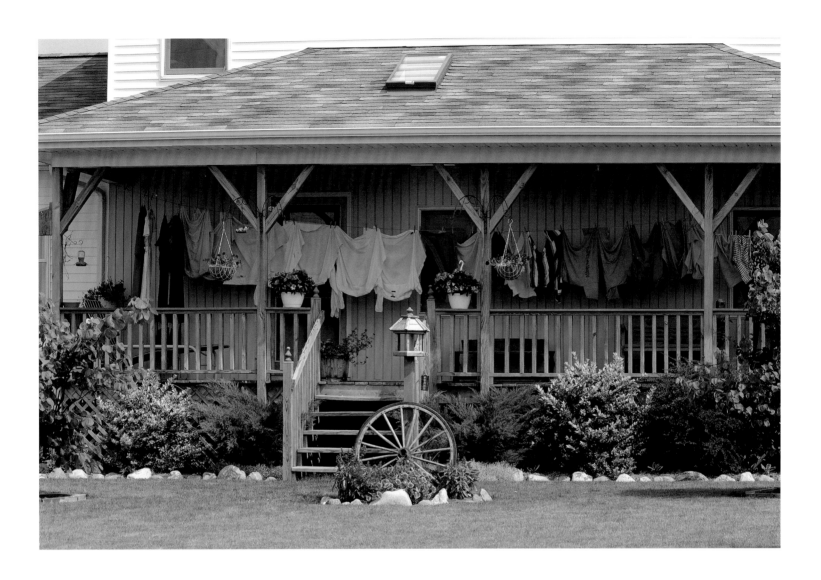

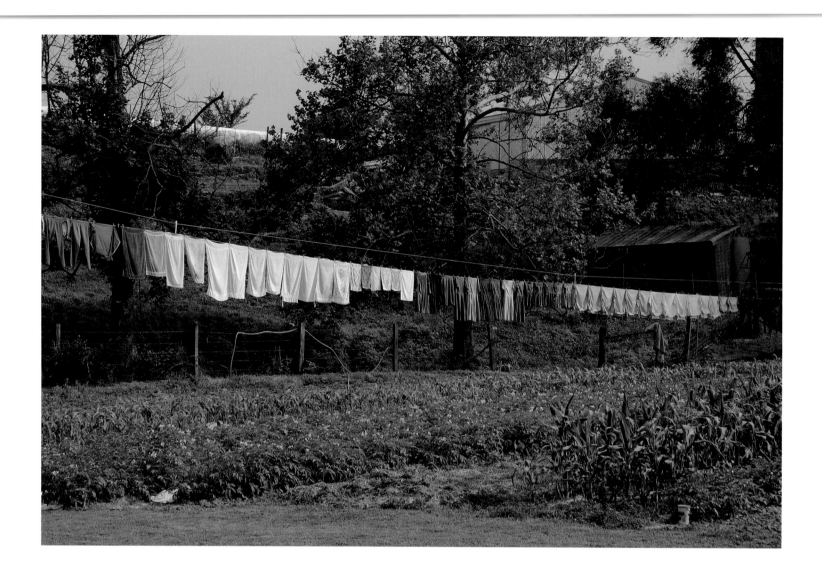

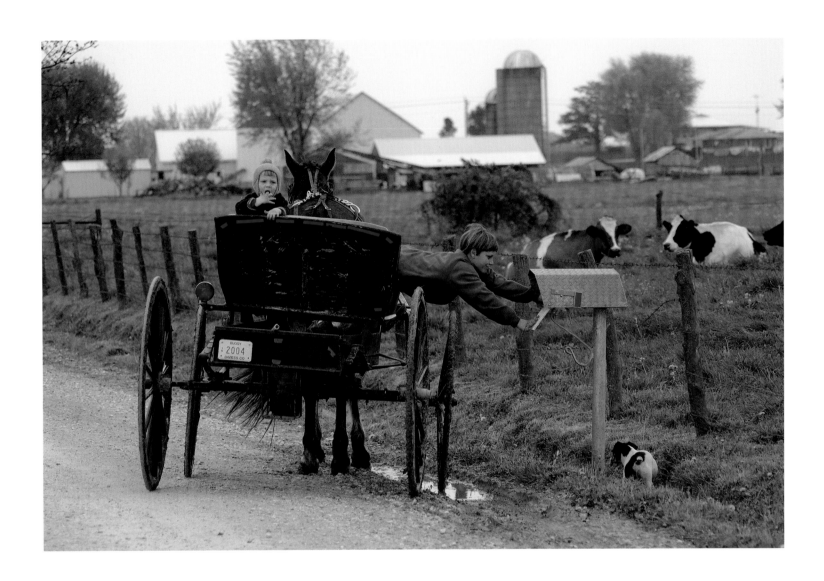

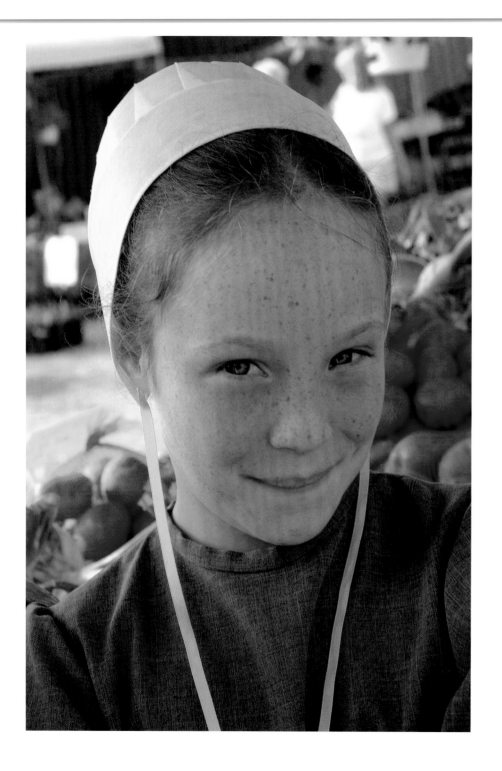

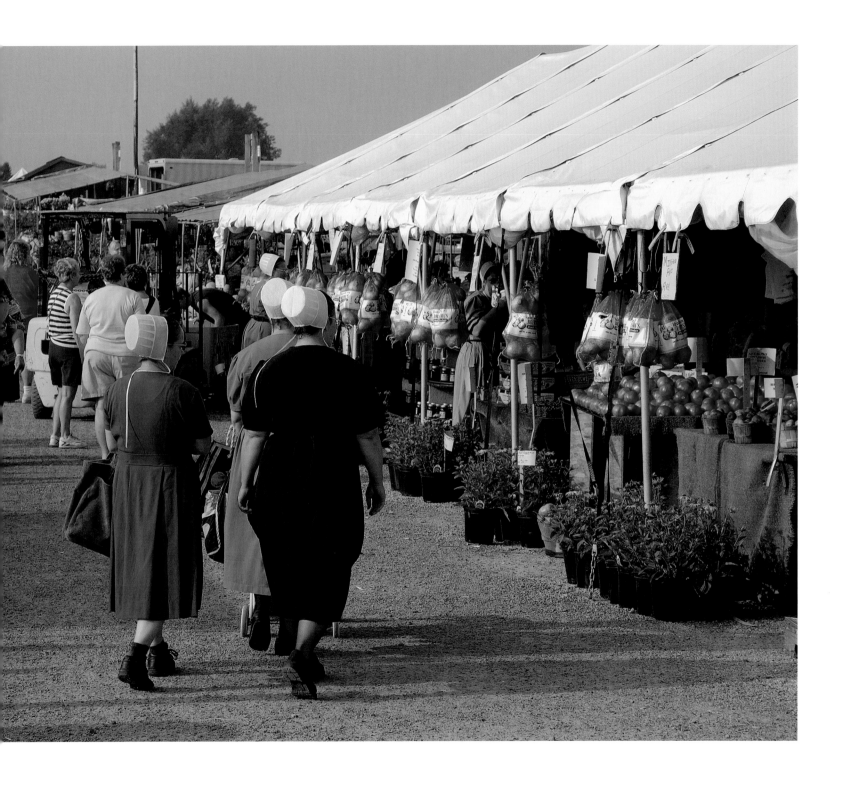

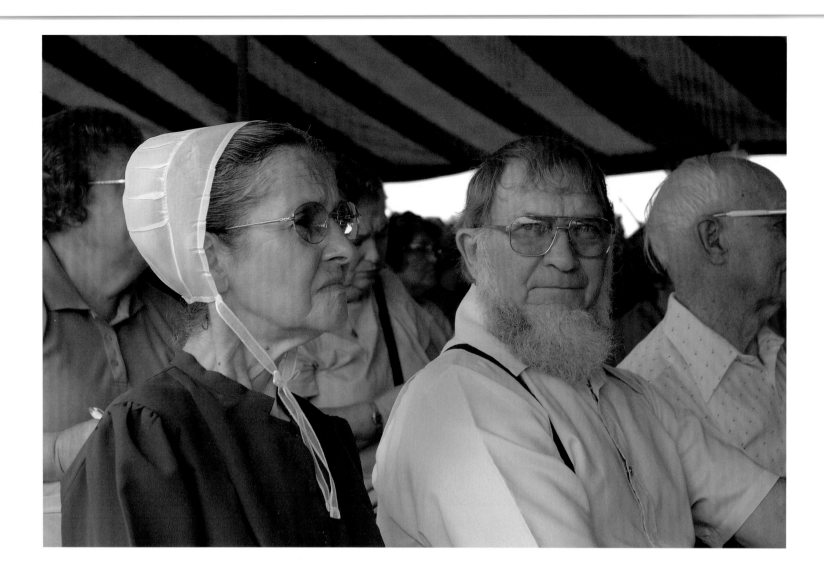

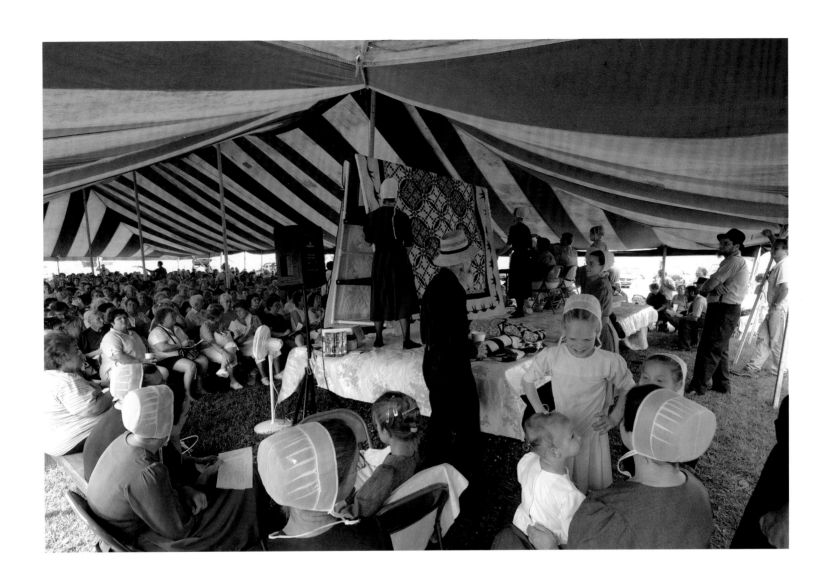

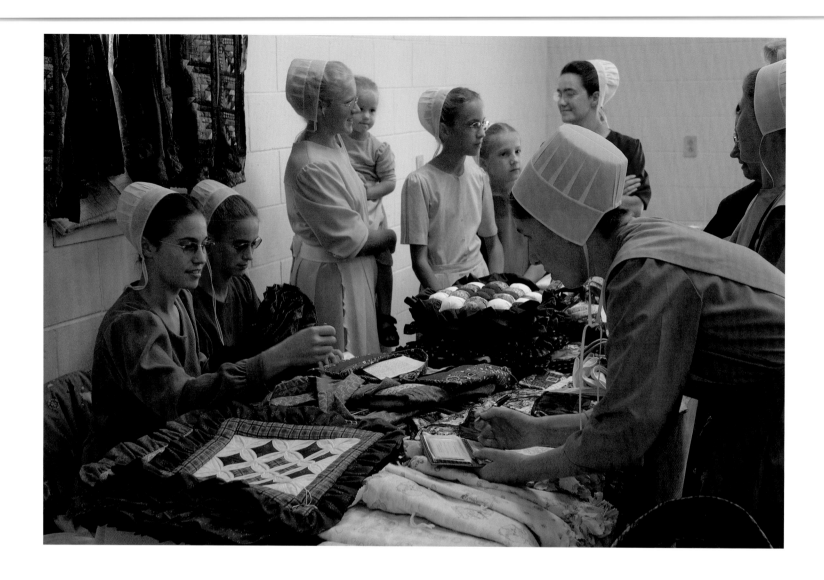

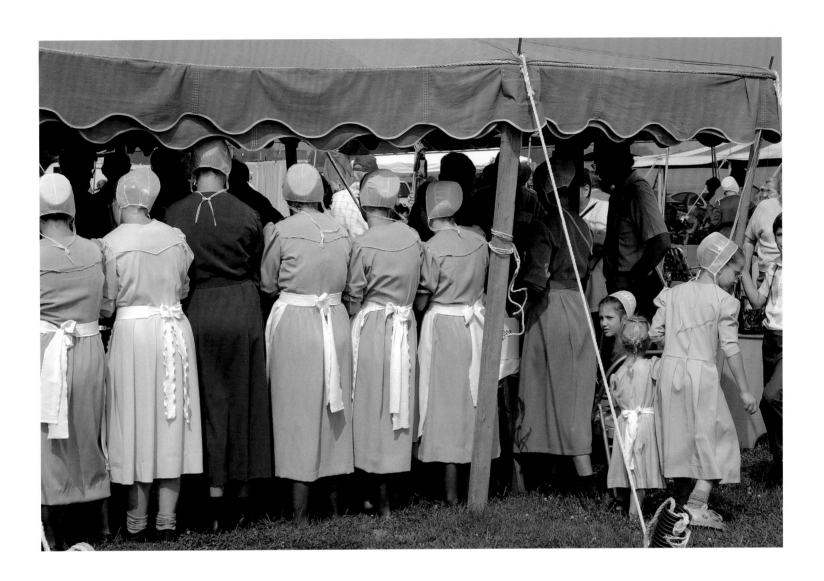

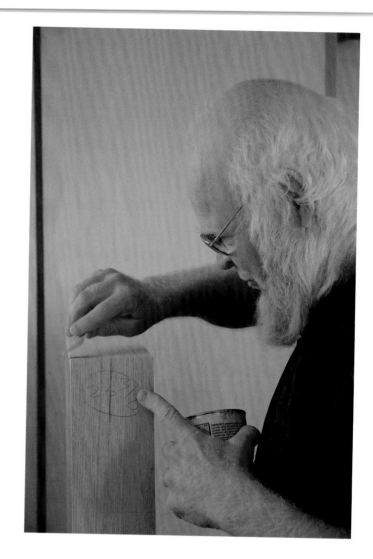

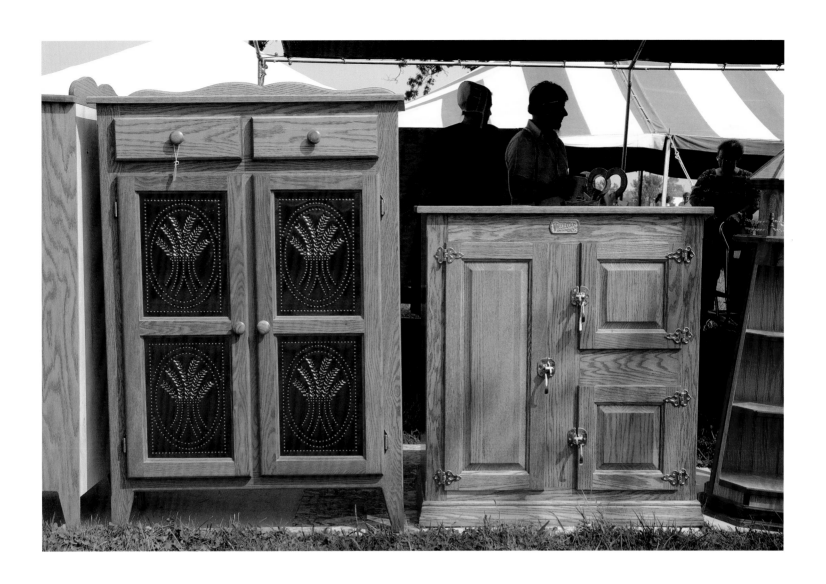

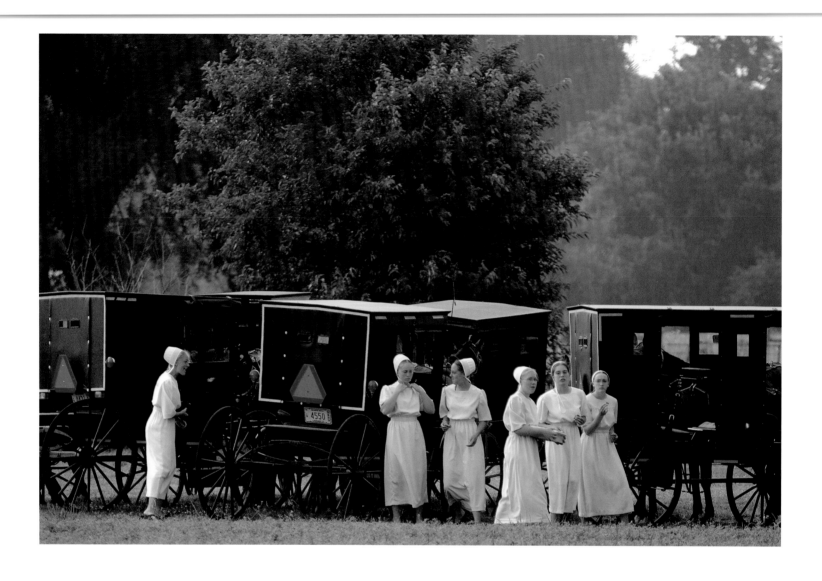

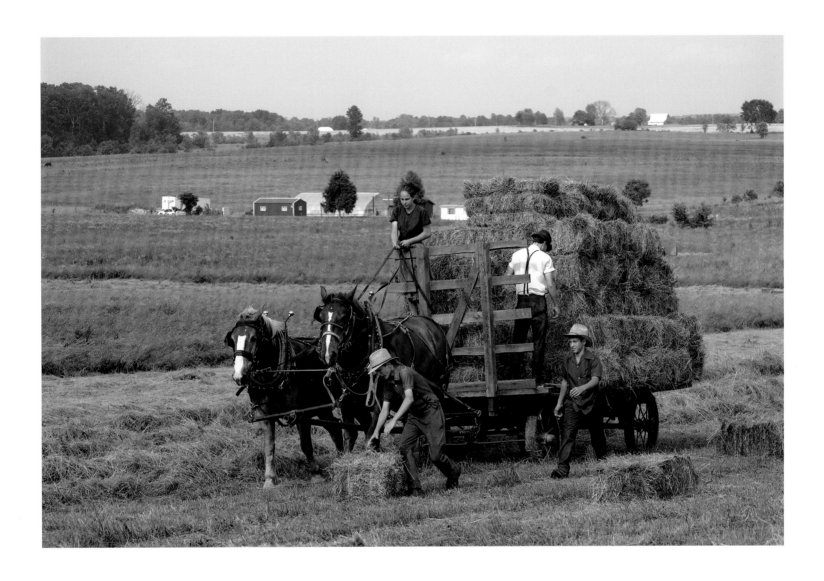

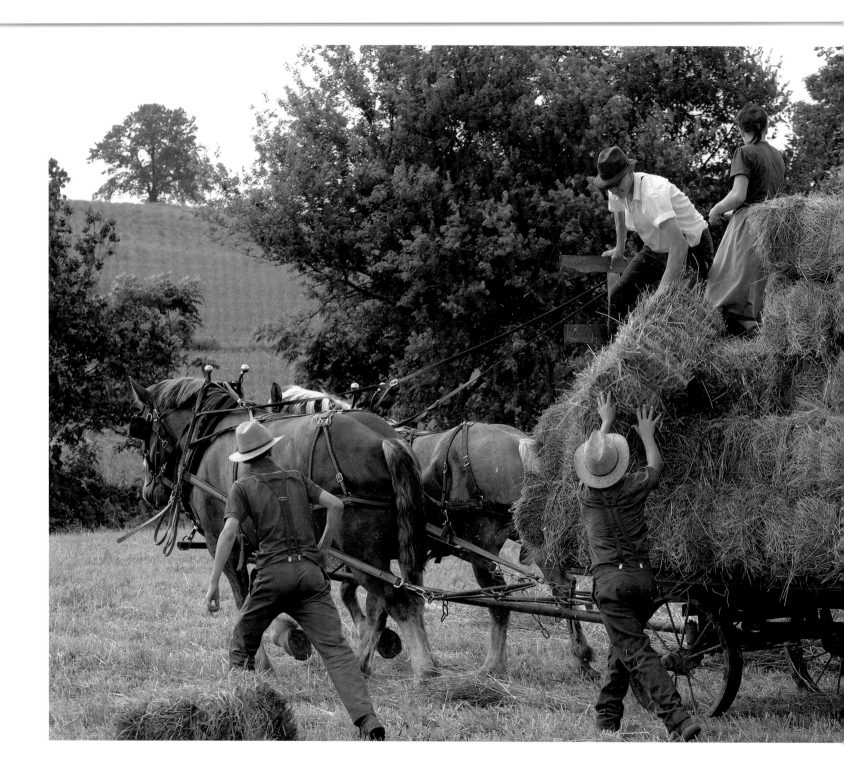

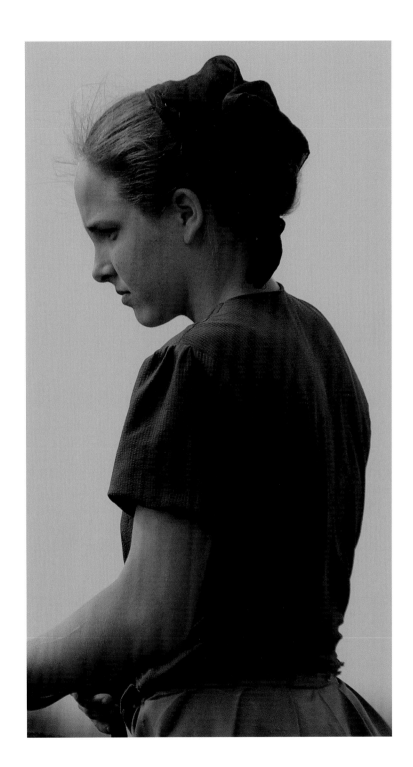

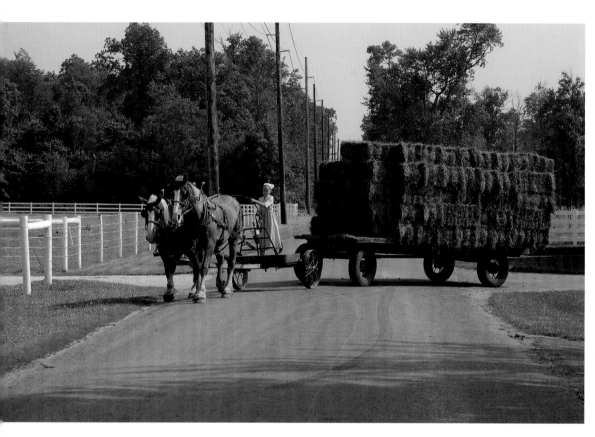

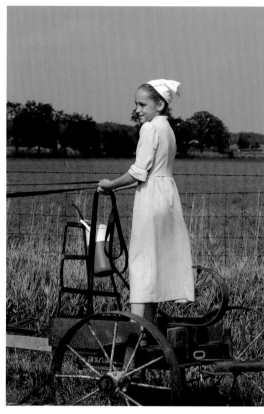

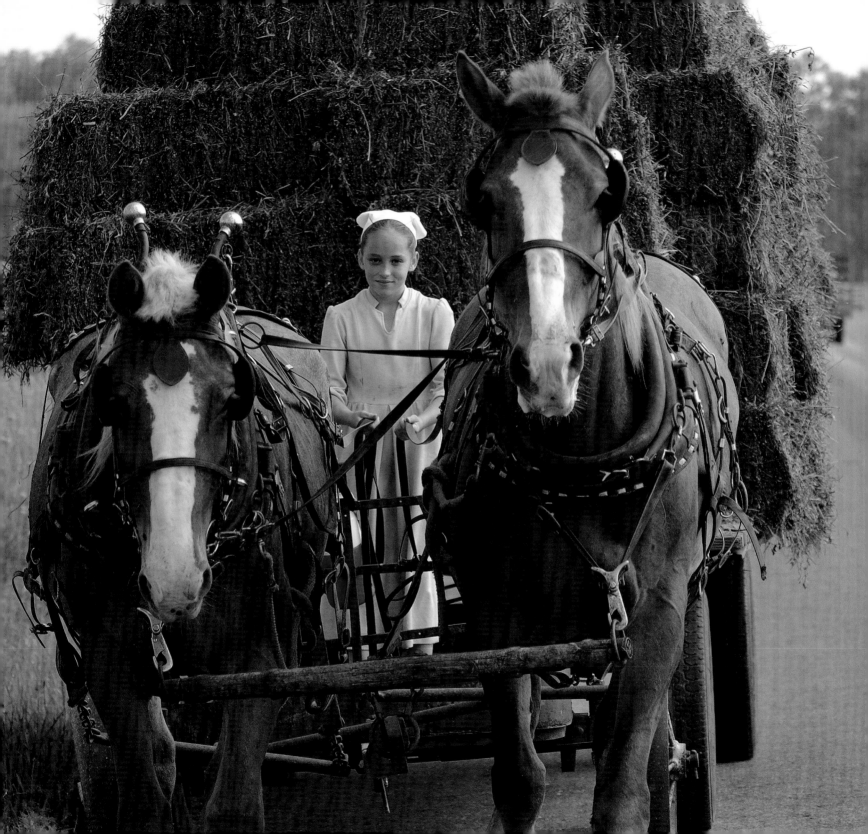

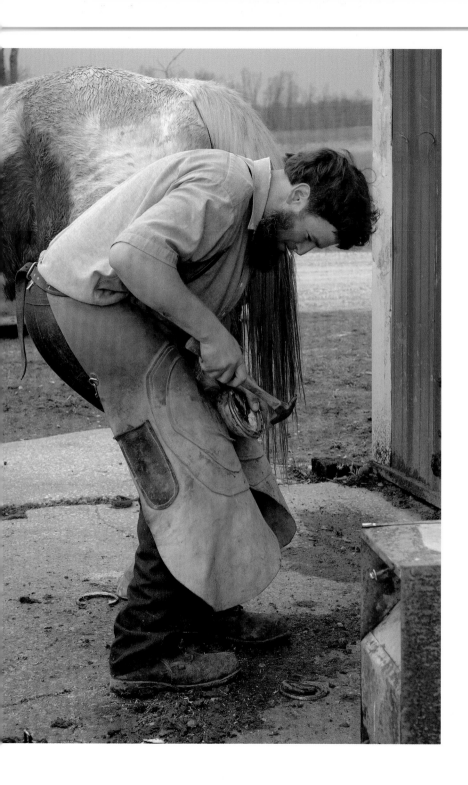

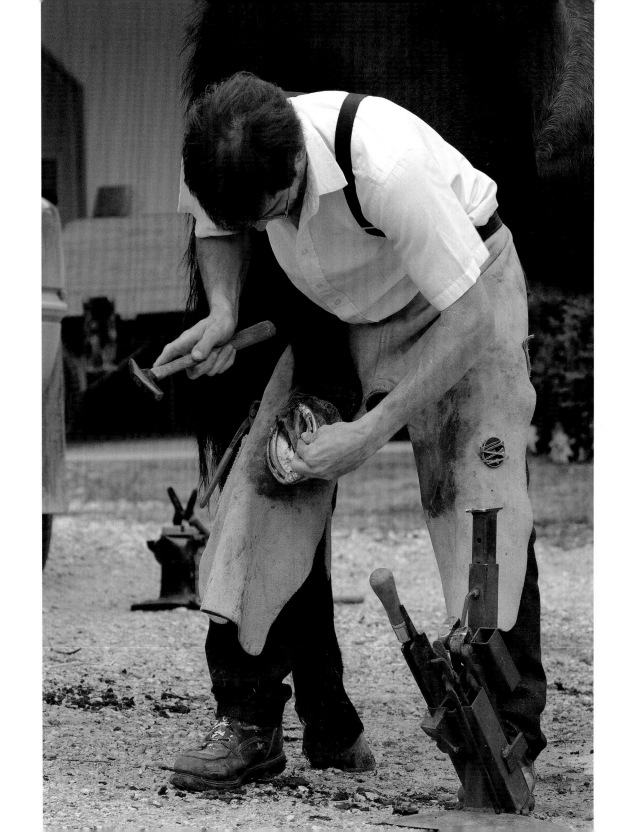

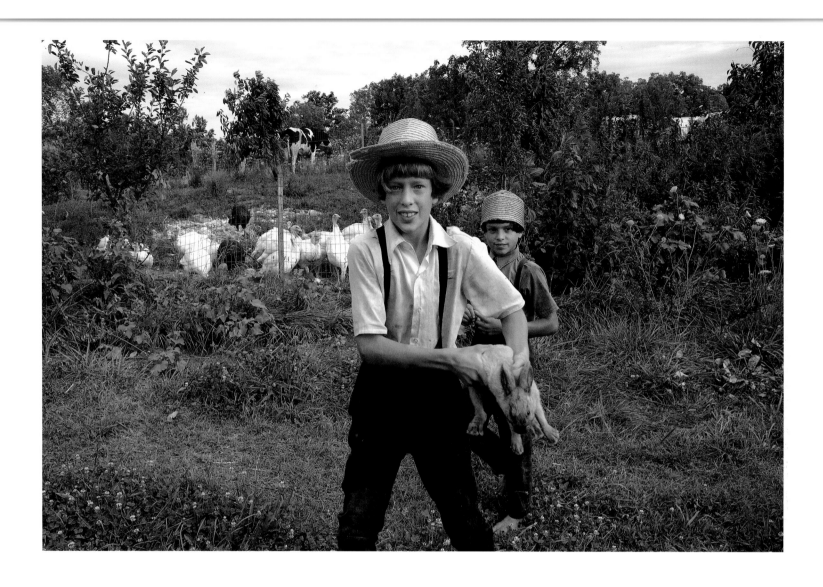

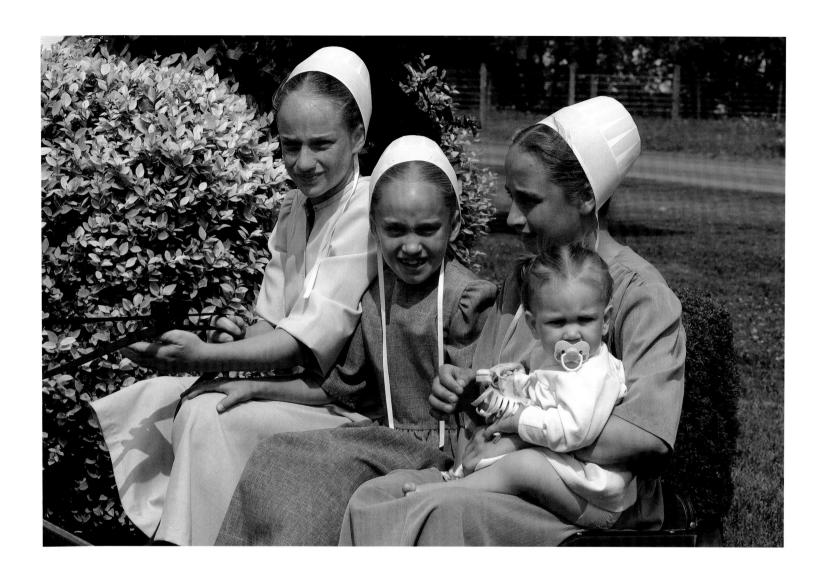

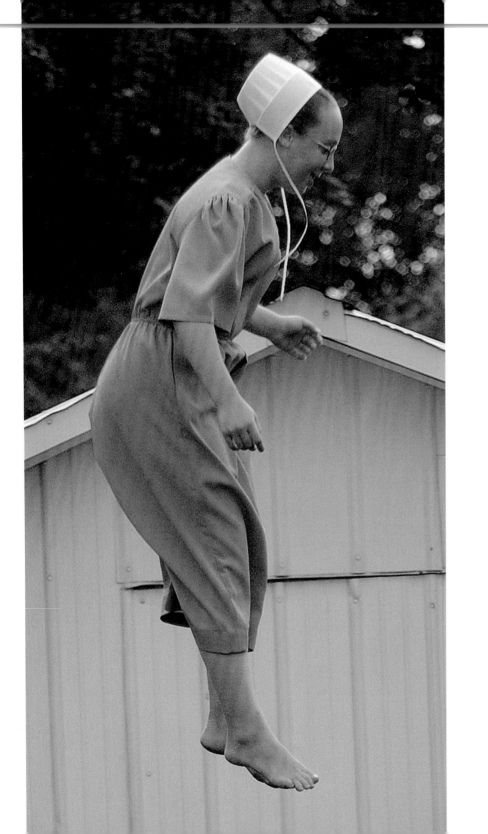

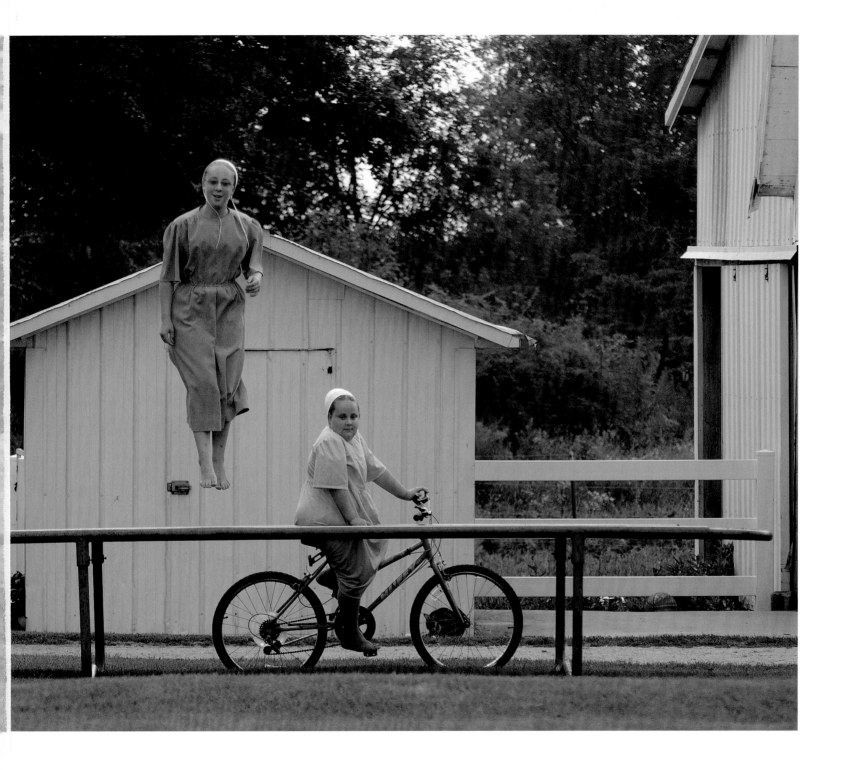

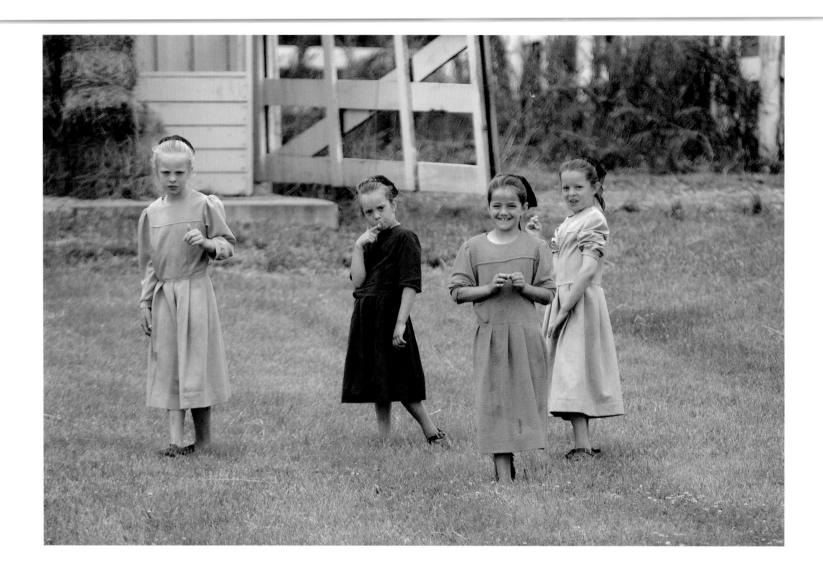

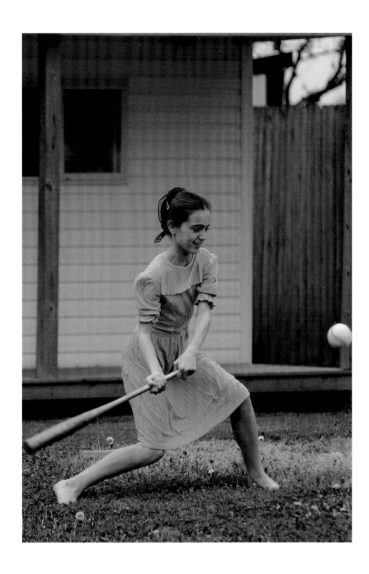

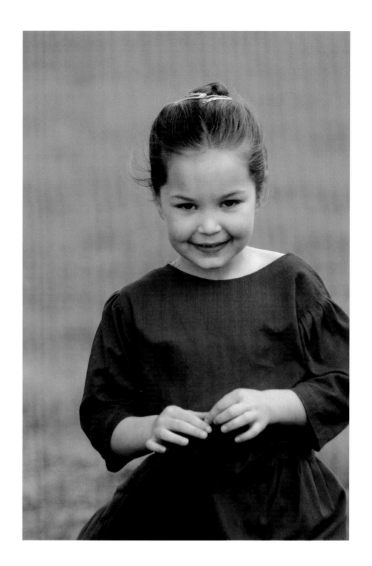

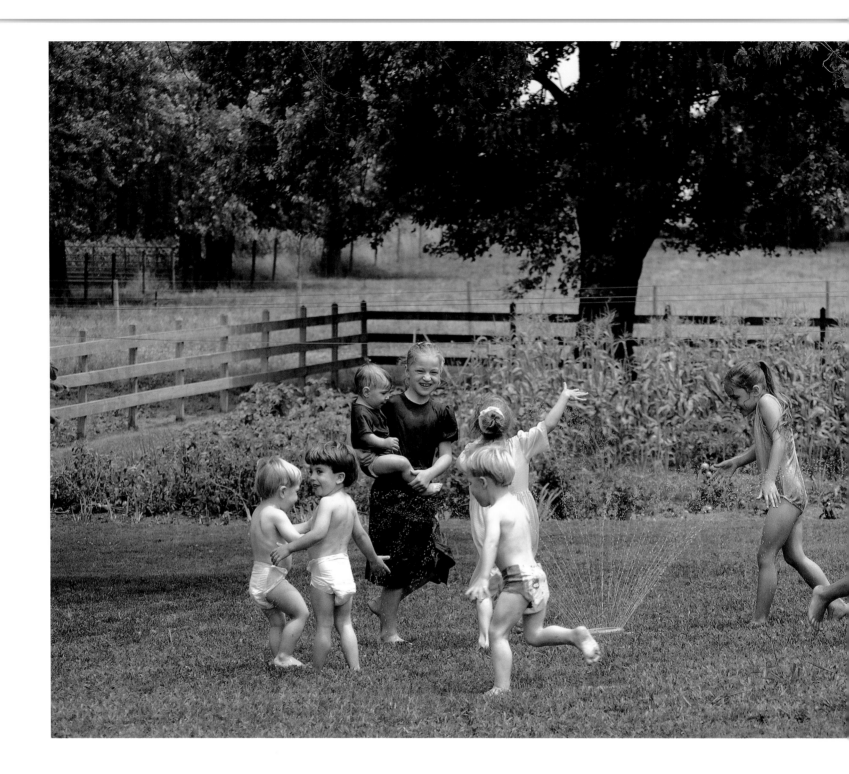

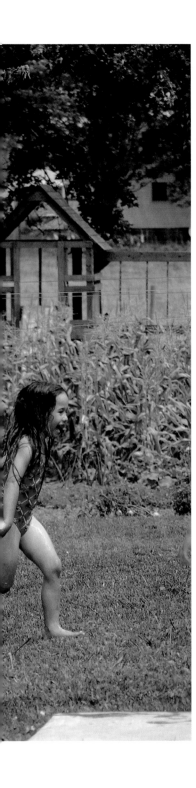
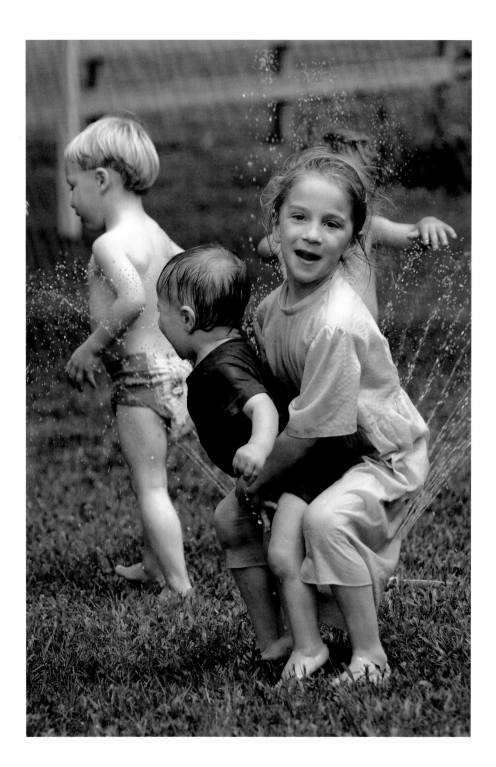

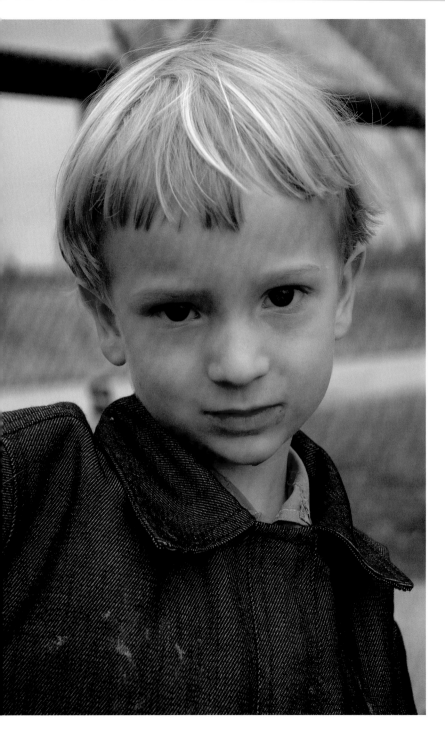
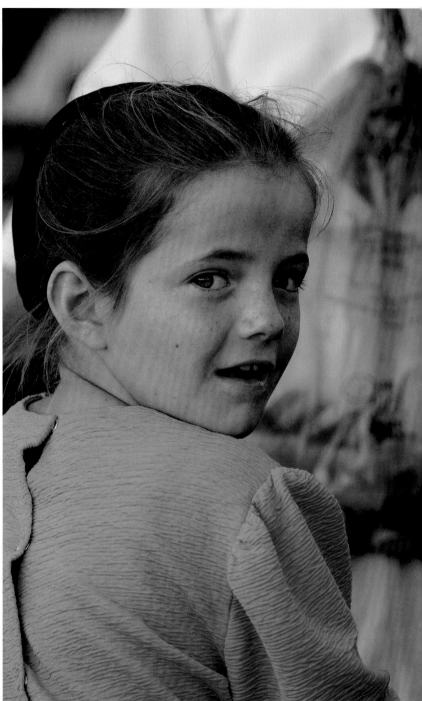

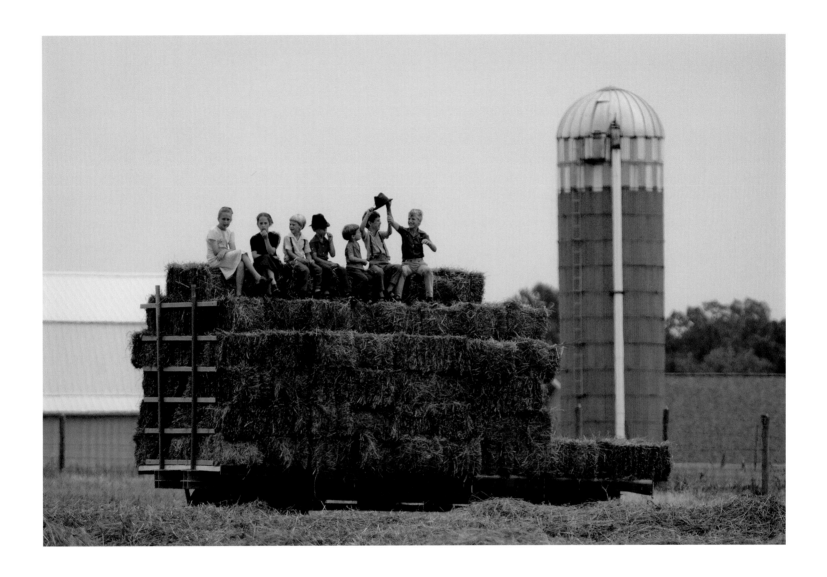

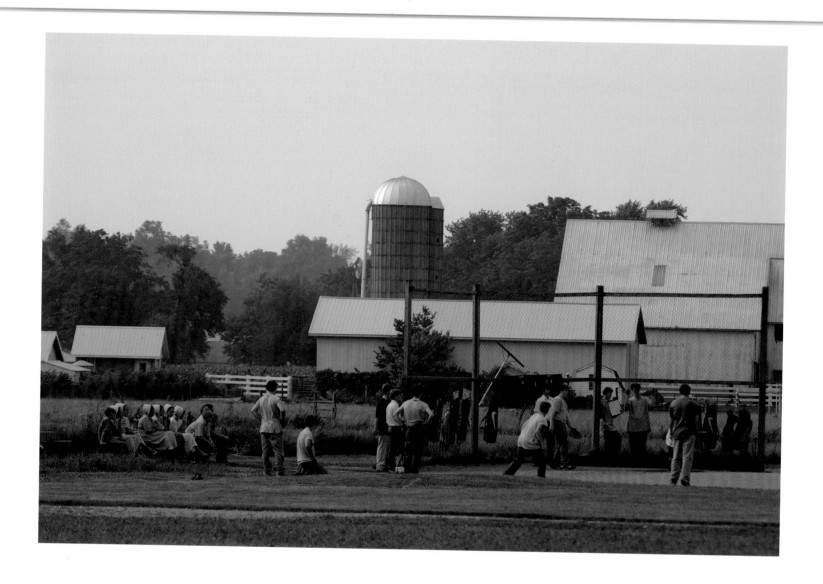

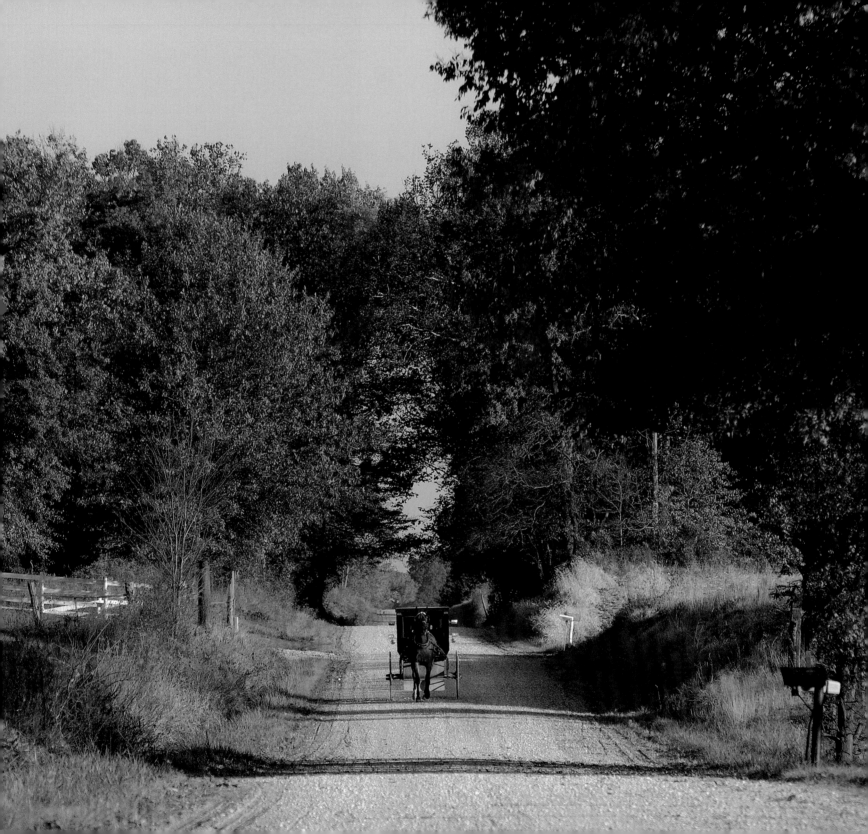

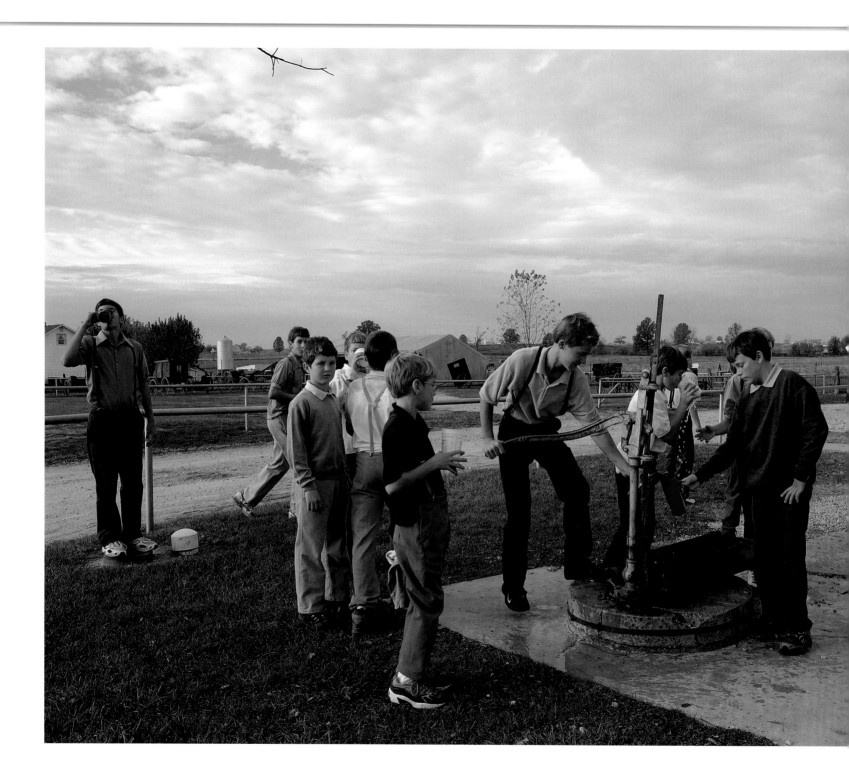

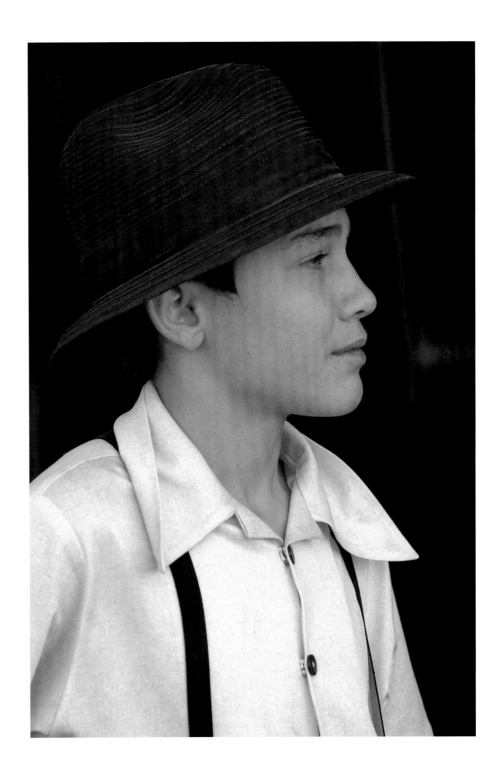

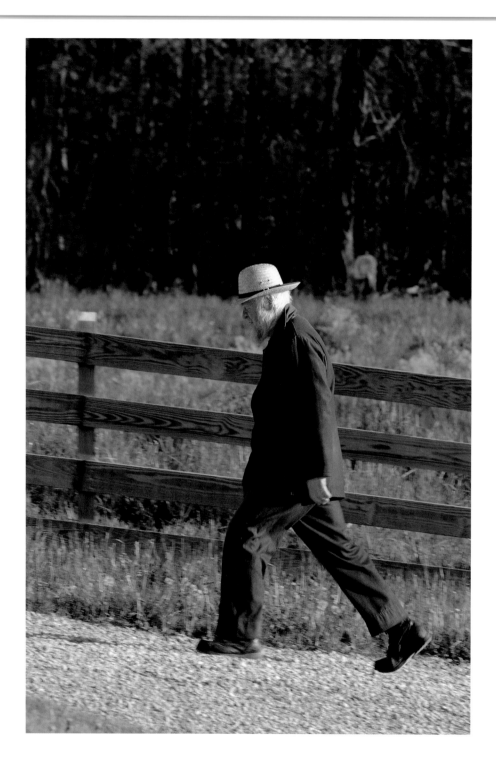

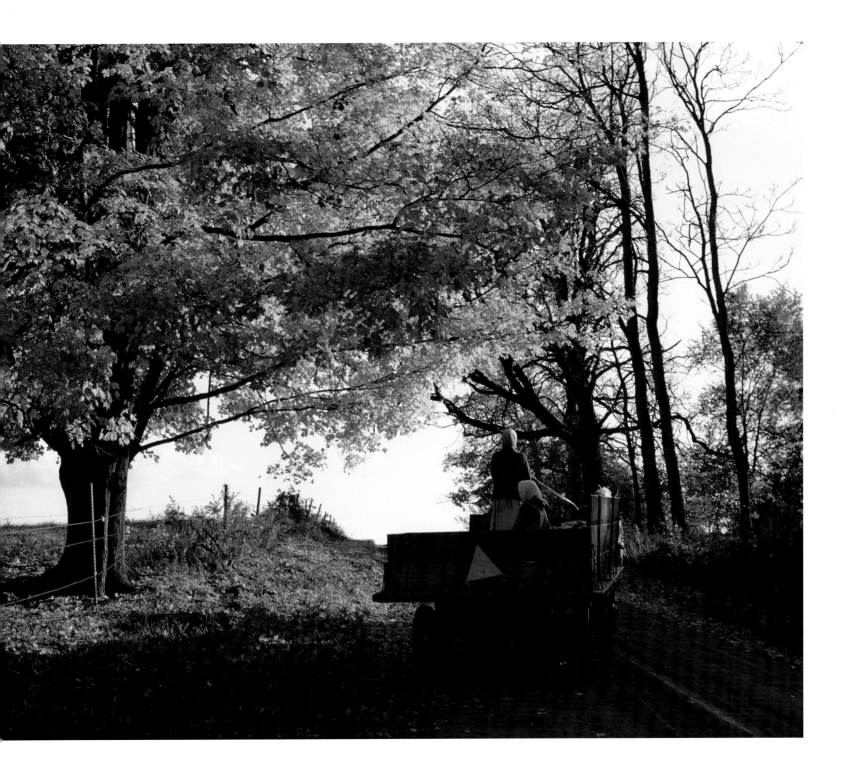

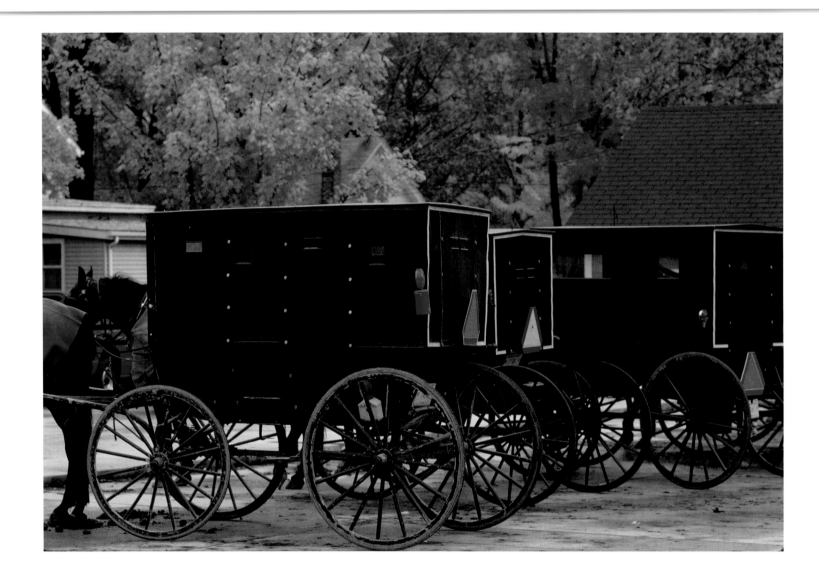

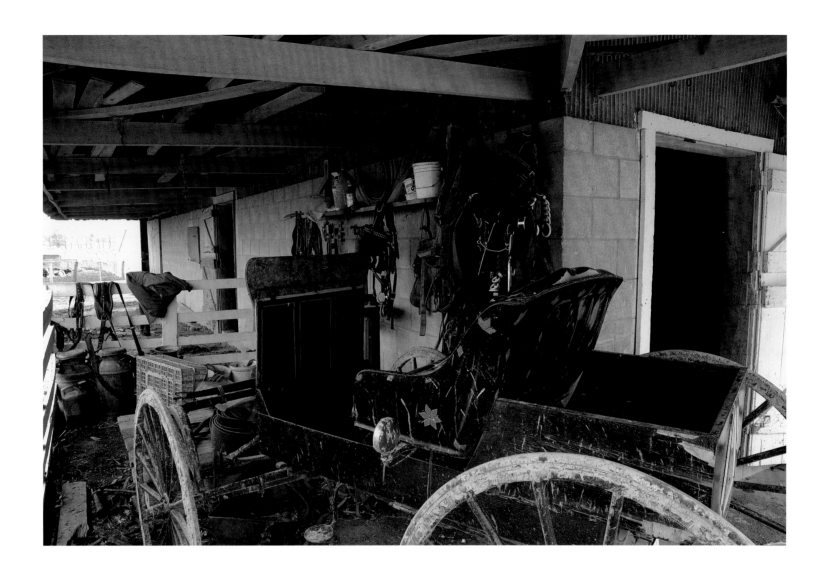

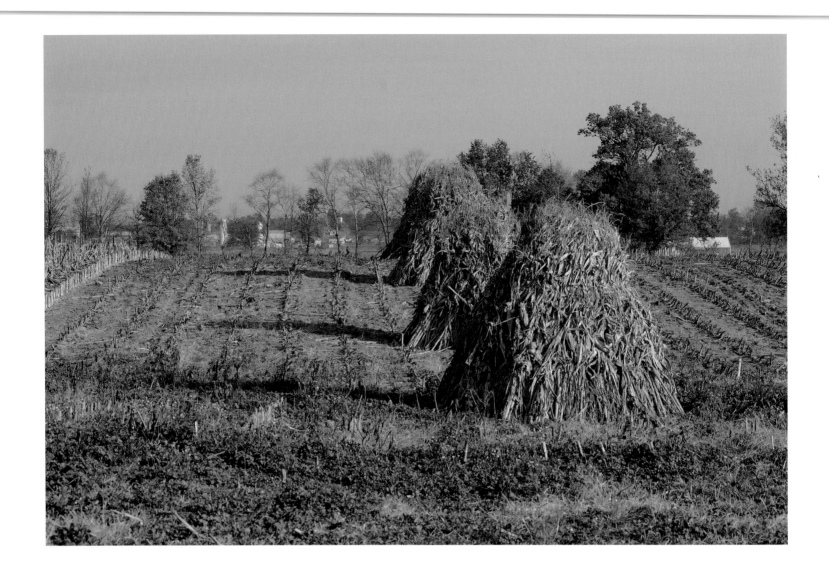

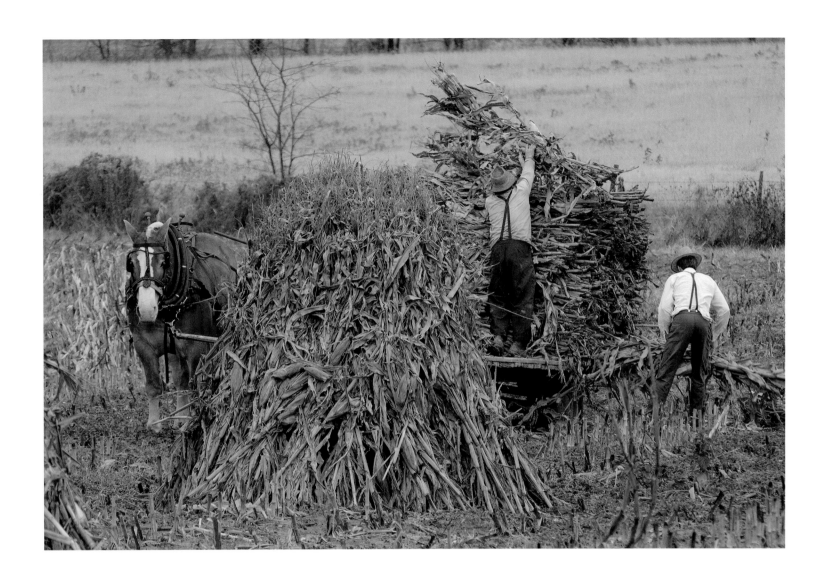

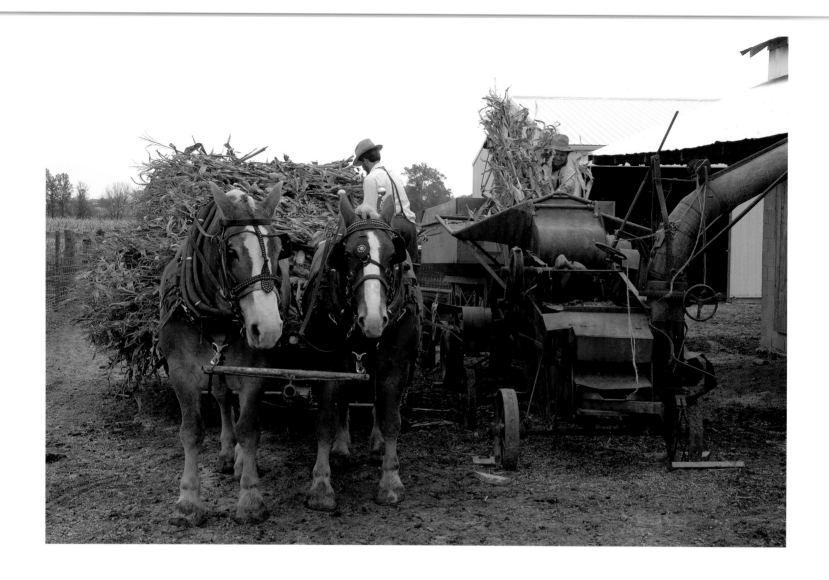

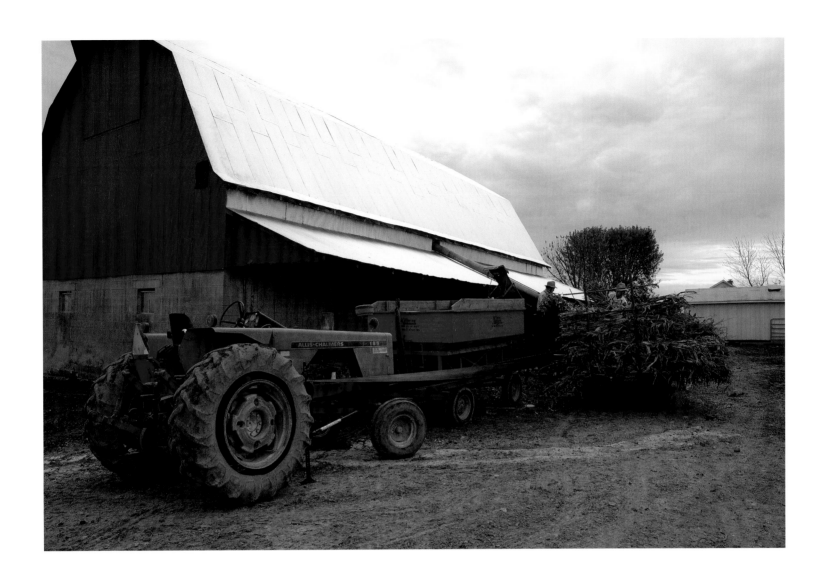

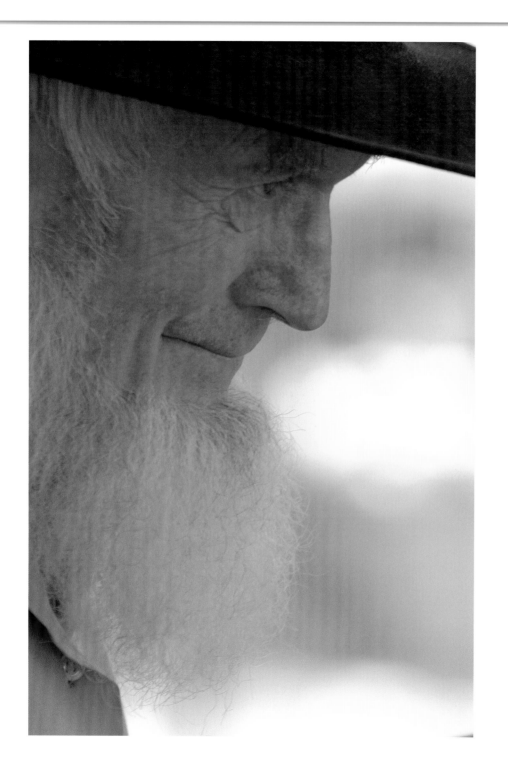

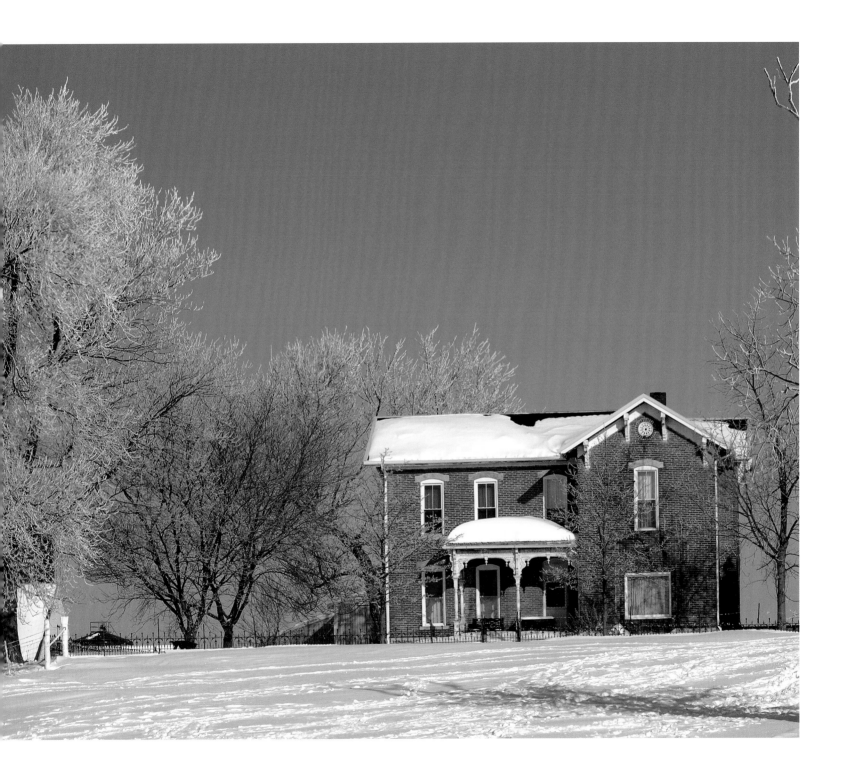

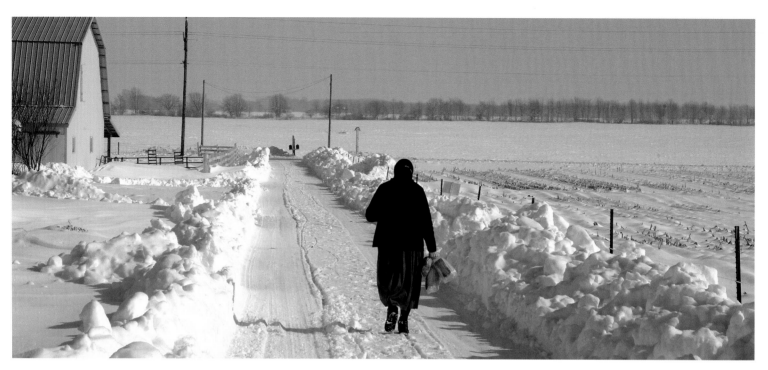

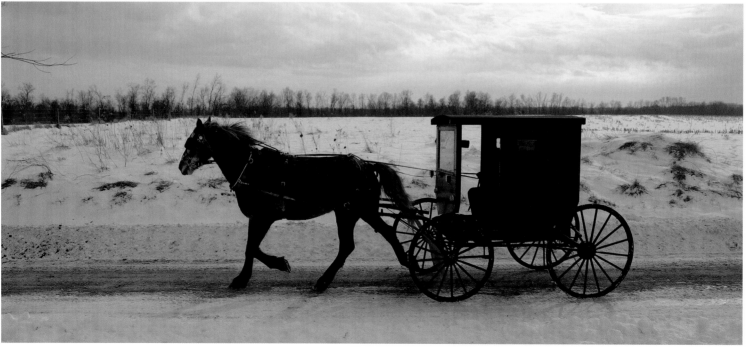

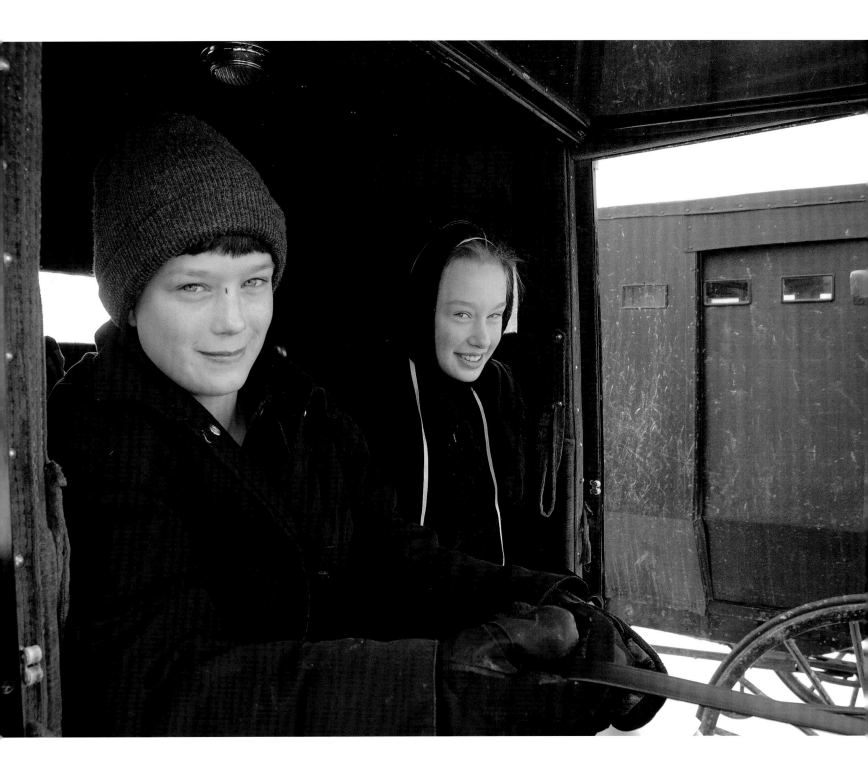

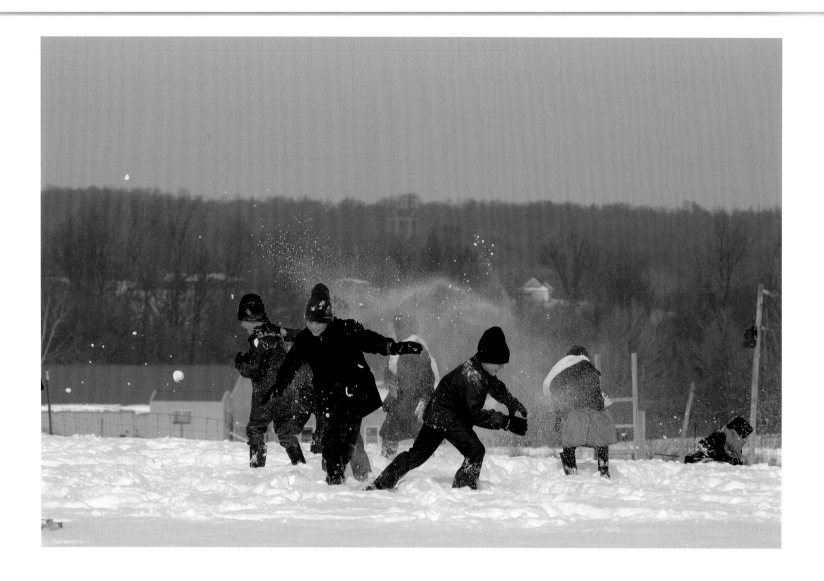

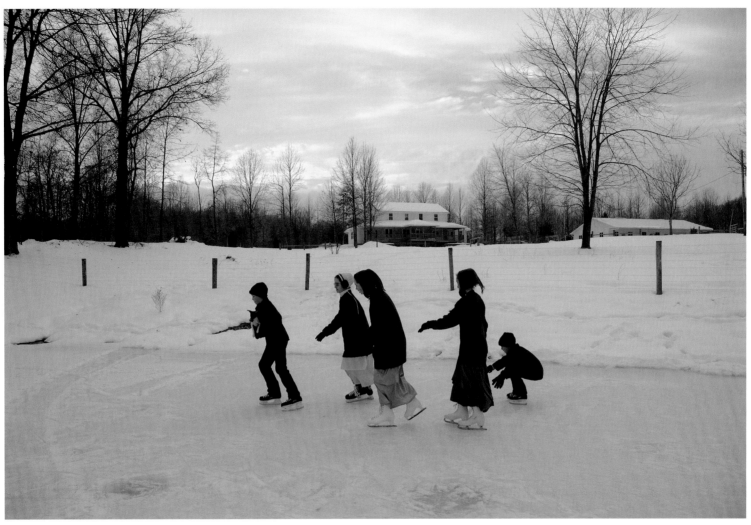

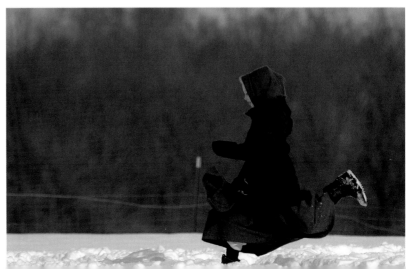

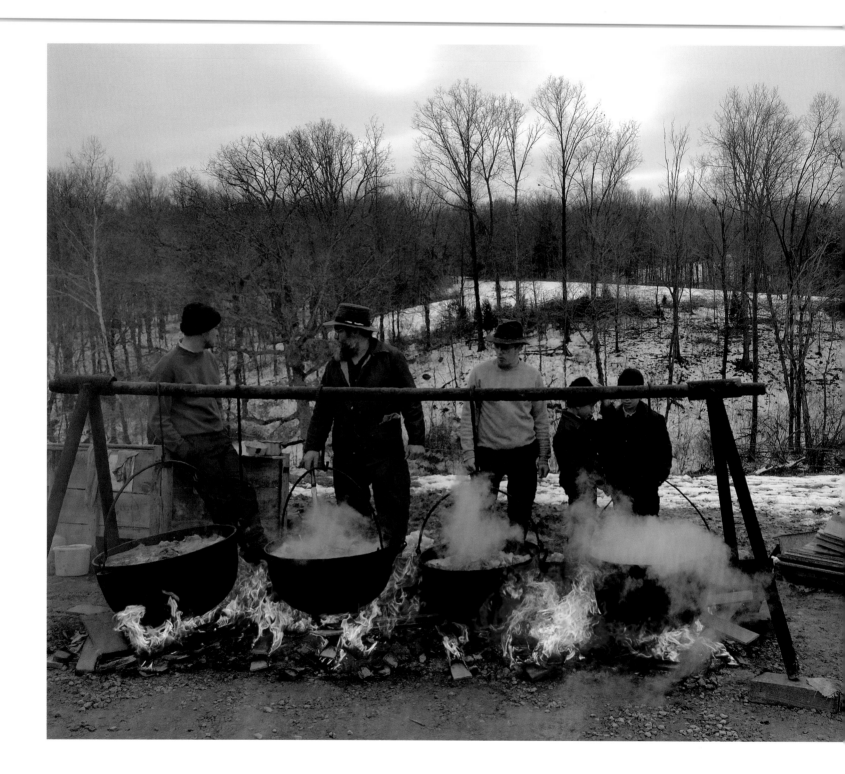

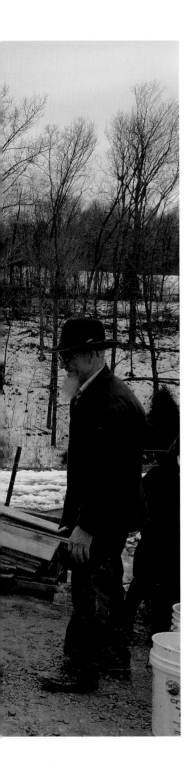

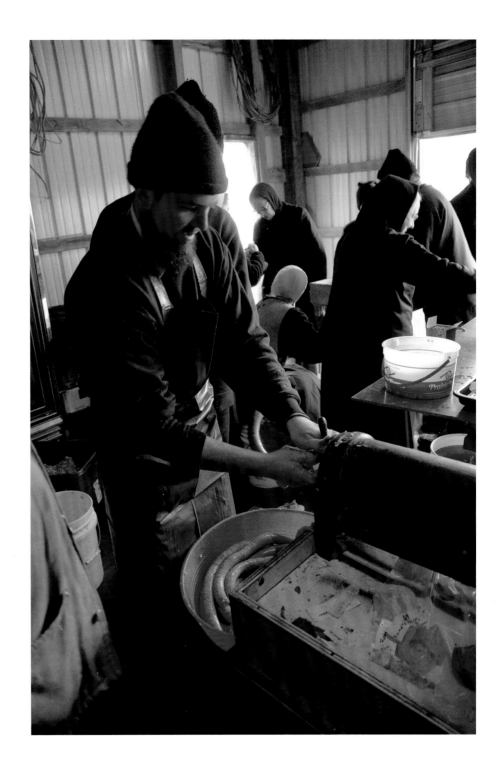

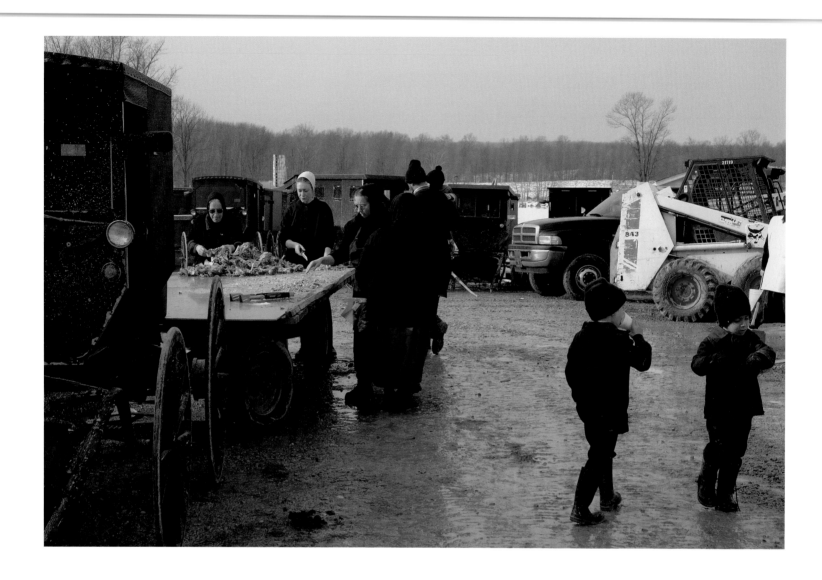

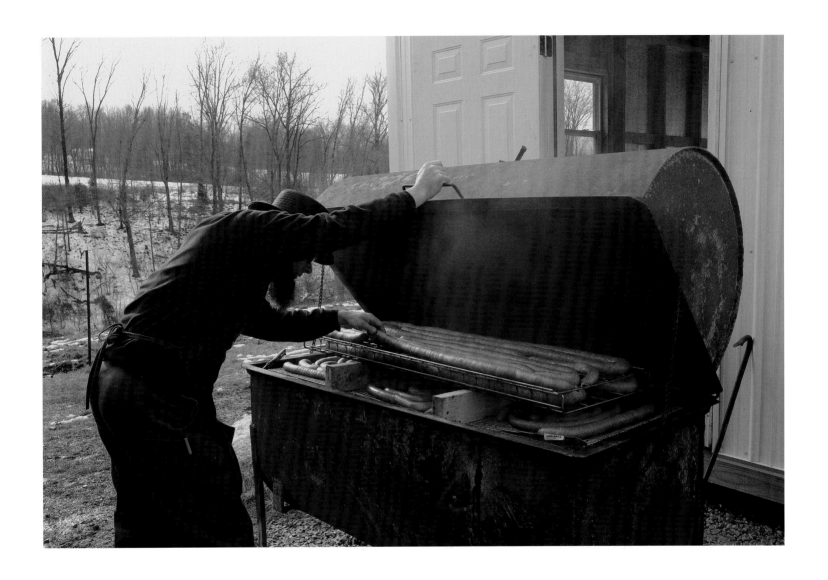

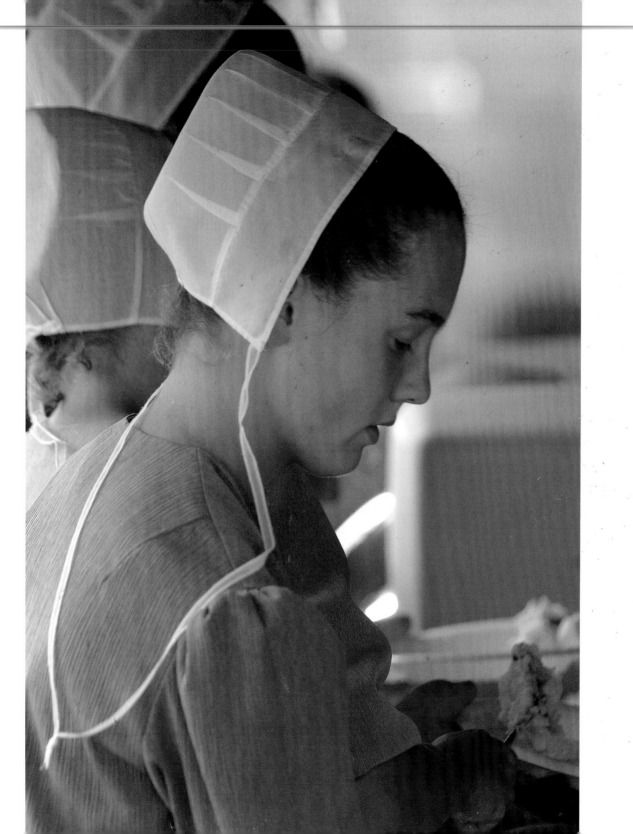

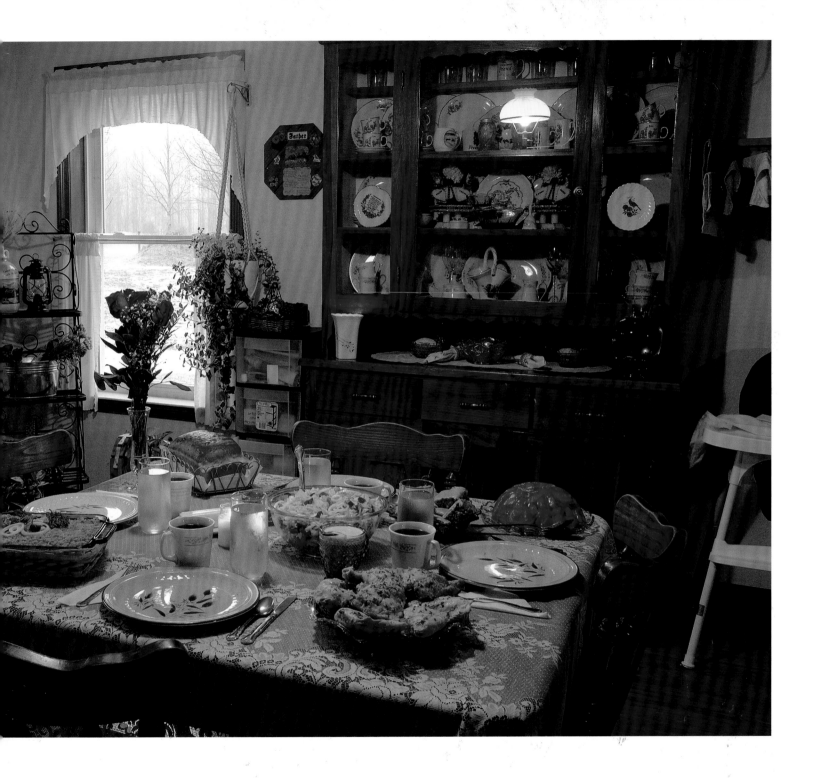

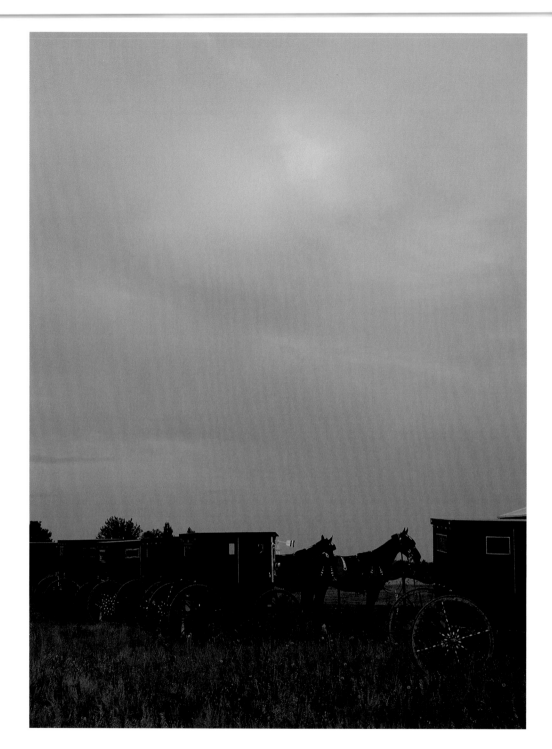

DARRYL D. JONES has exhibited his photographs in New York, in Boston, and throughout the Midwest. Among his books are *Spirit of the Place* (Indiana University Press, 1995) and *Indianapolis* (Indiana University Press, 1990). He lives in Freedom, Indiana.

H. 3/10